FOCUS ON WATERCOLOR

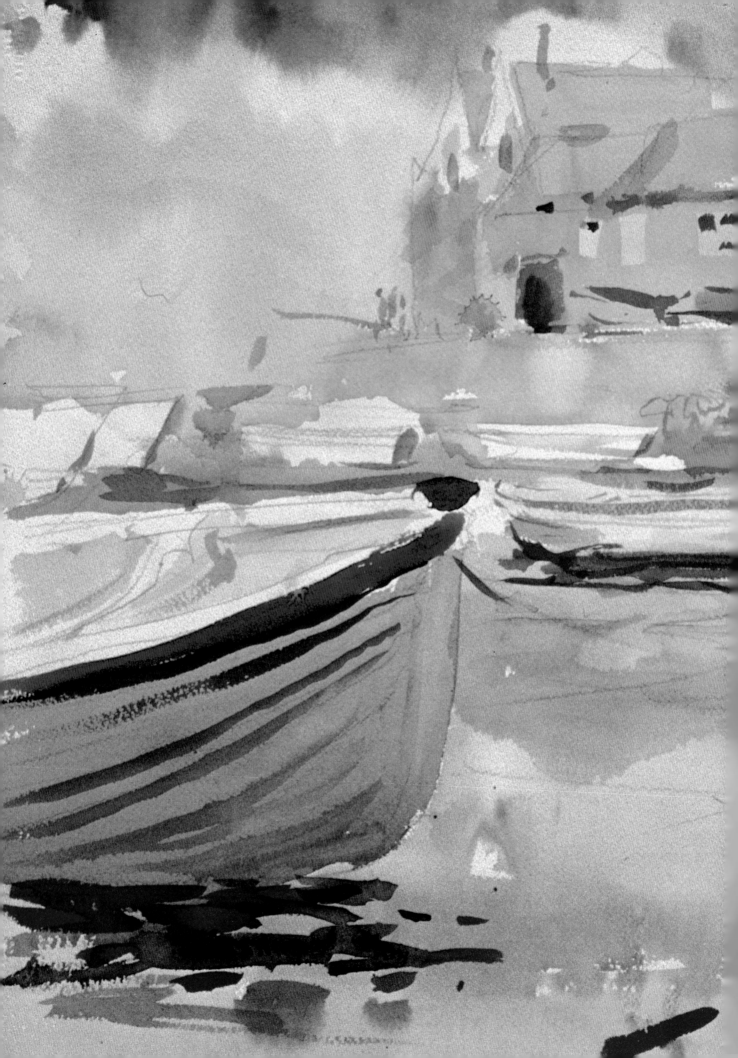

FOCUS ON
WATERCOLOR

TIMOTHY J. CLARK

WATSON-GUPTILL PUBLICATIONS / NEW YORK

Art on half-title page:
Cotswold Entry, 22'' x 15'' (56 x 38 cm)

Art on title page:
Mousehole Harbor, 15'' x 22'' (38 x 56 cm)

Edited by Sue Heinemann
Design by Bob Fillie
Graphic production by Ellen Greene
Text set in 11-point Century Old Style

Copyright © 1987 Timothy J. Clark

First published in 1987 in New York by Watson-Guptill Publications,
a division of Billboard Publications, Inc., 1515 Broadway,
New York, N.Y. 10036

Library of Congress Cataloging-in-Publication Data

Clark, Timothy J.
 Focus on watercolor.

 Includes index.
 1. Watercolor painting—Technique. I. Title.
ND2420.C53 1987 751.42'2 87-18976
ISBN 0-8230-1858-X

Distributed in the United Kingdom by Phaidon Press Ltd., Littlegate
House, St. Ebbe's St., Oxford

Manufactured in Japan

First printing, 1987

1 2 3 4 5 6 7 8 9 10/92 91 90 89 88 87

To my wife, Regina

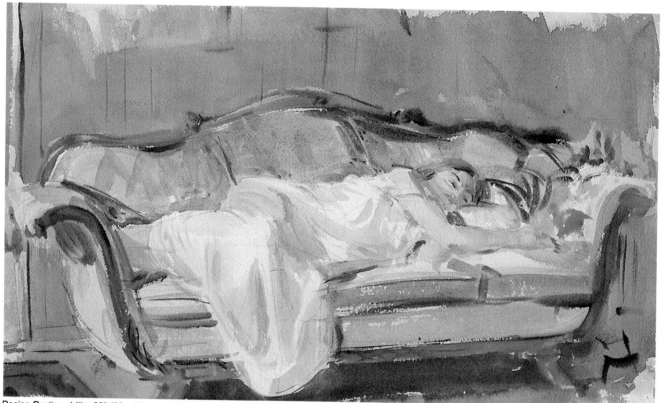

Regina Resting, 14" x 22" (36 x 56 cm), collection of the artist

THANKS

To Mary Suffudy, for her early editorial guidance on this book.

To Sue Heinemann, for seeing it through to the end.

To Bob Fillie, for his sensitive design.

To Glenn Heffernan and Steve Doherty, for their continued support.

To Dr. Robert Wark of the Huntington Library, for his generous help.

To my students, for serving as guinea pigs for these lessons.

To the late Don Graham, for teaching me to compose and draw.

To Harold Kramer, for being a great teacher and painter.

To all the many others who helped me along the way.

To my parents, who encouraged and supported me.

To Regina, my wife, for not only understanding me, but also my handwriting.

And special thanks to my three daughters.

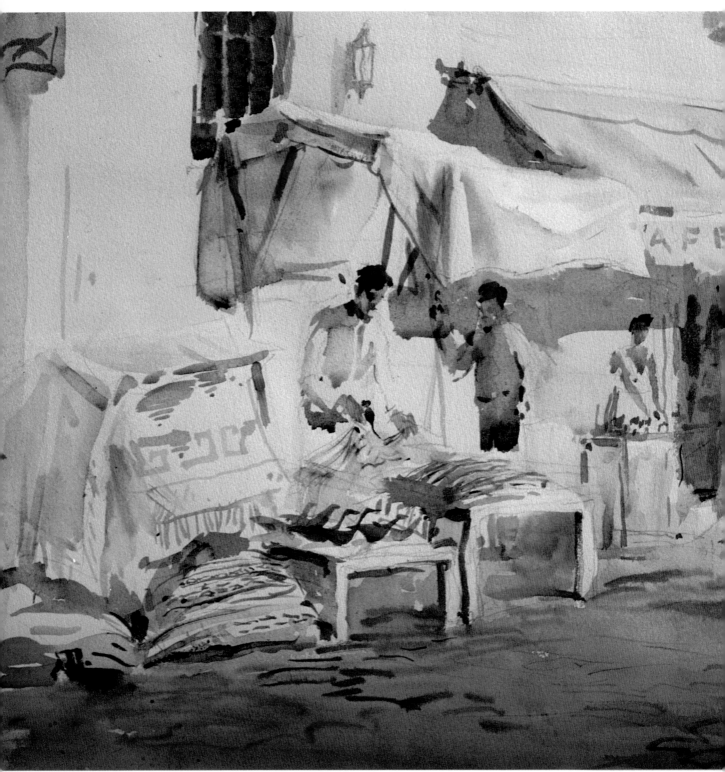

Zihuatanejo Market, 15" x 22" (38 x 56 cm), collection of John and Karen DePietro

CONTENTS

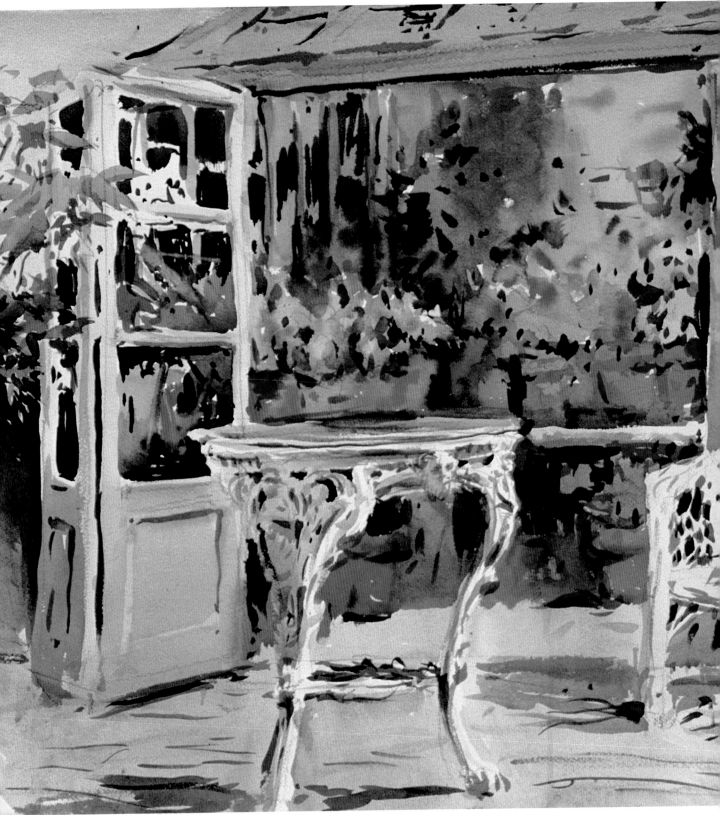

Judy's Garden, 20'' x 25½'' (51 x 65 cm)

INTRODUCTION

As an artist, I've learned how to work in several different media, but the one I've focused my career on is watercolor. In this book I intend to explain how many important painting issues relate specifically to watercolor and to introduce you to some of the many exciting challenges for the artist working in this medium.

Essentially, I believe there are three major areas of concern for any artist: expression, concepts (including the basics of composition and ideas from the history of art), and techniques. When all three of these elements are working together, creativity is at its peak. But when one becomes too dominant, the creative process slows down. What good, for example, is wonderful technique without emotion? And how can emotion be expressed without technique?

In putting together this book, I have tried to fashion a balance of these three elements, giving you some hard-and-fast rules, some more flexible theories, and some advice on how to honestly pursue your own direction. The chapters on drawing, palette control, and watercolor techniques should supply you with the essential technical skills. The discussion of composition and the brief survey of wa-

tercolor history should then help you to build on an established graphic language. Although expression is touched on in every chapter, it is the specific focus of the seventh chapter, "Finding What's Important to You."

There are many different ways to use this book. Besides reading it in page order, you can choose certain lessons at random or look up specific topics of interest to you at the moment. Another possibility is to read the first section of each chapter and then complete a painting on your own; next go on to read the second section and do another painting. After you've completed all the subsections, you might conduct a chapter-by-chapter review to gain a more complete understanding. One point to remember: although practicing exercises is helpful, doing exercises is not as important as creating paintings on a regular basis.

Ever since I was a child, I have been "thirsty" for knowledge about art. This thirst led me to study at four art schools and three colleges. But even that wasn't enough. I'm still thirsty. The best way I've found to satisfy that thirst is to keep on painting. The more you paint, the more you'll learn.

DRAWING FOR THE WATERCOLORIST

What do J. M. W. Turner, Edgar Degas, and Andy Loomis have in common? This may surprise you, but they were all told they did not have talent in drawing. All three, however, refused to believe the "experts." They knew in their hearts that they could draw and paint—and they went on to do just that, regardless of what others thought.

If the so-called experts told two very fine painters and a popular illustrator that they didn't know how to draw, they may have told you the same thing. Their remarks aren't important. What *is* important is that you learn to enjoy drawing. Once you enjoy drawing, you will become better and better at it. You will spend more time drawing, gain confidence, and open yourself up to new ideas. And, as your drawing improves, so, too, will your painting.

Don't get stuck and think that there is only one way to draw. I have about four or five different approaches to drawing. If one isn't working too well for me on a particular day, I'll try another, switching my method just a bit. My personality, however, always comes through, so it ends up looking like my style.

Let's look at the four approaches I use most frequently. The first is simple and direct: it involves blocking in the main shapes, which carry most of the information in the picture. Sometimes, however, I spend more time on perspective, measuring the angles of what I see. This second approach may sound complicated, but it needn't be (see pages 14–15). A third tactic is doing a contour drawing—which is a great way to increase your concentration. Finally, there's drawing sight-size—an old idea, often put on the back burner, but one that sure comes in handy sometimes.

Of course, there are many other drawing methods you might try. I've selected these four approaches to start with, not only because I like to use them, but also because they encourage the kind of drawing skills you need for watercolor.

Wade's Office,
22'' x 15'' (56 x 38 cm),
collection of Attilio and
Sheila Pecile Petgani

Blocking In the Shapes

The first drawing lesson is simply blocking in the main shapes. Holding the pencil at the end, so you don't get too involved with skill or detail, just put simple shapes down wherever you want the main shapes to go. You might call this "the dictator's method of drawing" because it says in almost simplistic terms: "The house is going here." Later, in the chapter on composition, we will talk about placing objects in a way that makes the picture more interesting. For now, however, just block in a few simple shapes and don't worry about details.

The next step is to refine the objects. One way to add some authenticity and arrive at a good preparatory drawing is to ask the visual question: Which side gives me the clearest view? Whichever side it is, make sure that it becomes dominant. The other side (the one that turns away from you) must be discounted and drawn much smaller. In other words, you play a short side against a main side. A natural design choice and good drawing become rolled into one.

This is a simple way of starting a drawing, not a detailed, finished method. You can almost forget skills, and with a fairly light touch of your pencil, just say, "I want this to go here and that to go there." Once the main shapes are in, you can continue to make further observations and add more information. This method works well whether you are drawing from life or a photograph.

Begin by sketching the basic shapes of the objects.

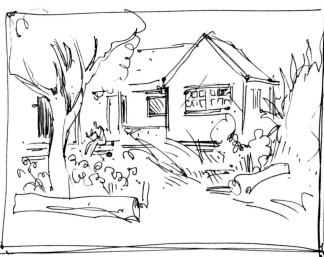

Next start to refine the shapes and add smaller shapes, like the figure and windows here, which are also important to the composition.

Try to choose a viewing angle that allows you to show one side fully and another side partially. Also try to include a sliver of an edge, as in the view of the roof edge here. Combining both full and partial views in this way makes for good design and creates a feeling of space. Notice in the example here how the shape of the windows changes from the front to the side (where they are seen in perspective).

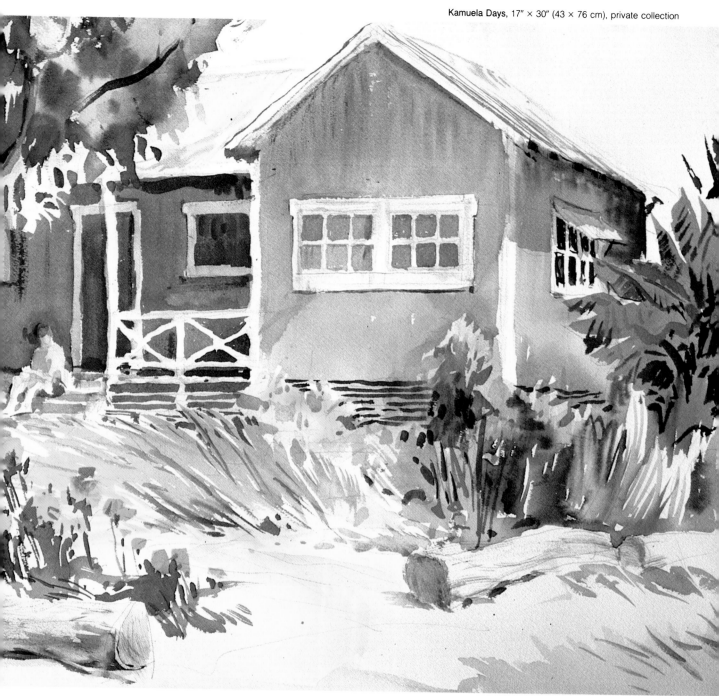

Kamuela Days, 17″ × 30″ (43 × 76 cm), private collection

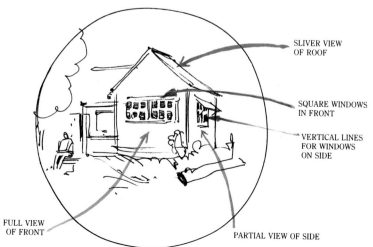

SLIVER VIEW
OF ROOF

SQUARE WINDOWS
IN FRONT

VERTICAL LINES
FOR WINDOWS
ON SIDE

FULL VIEW
OF FRONT

PARTIAL VIEW OF SIDE

Blocking in and then refining my drawing allowed me to control the placement of this old Hawaiian plantation house. Notice how the freely drawn plants, blowing in the breeze, offer a contrast to the geometric pattern of the windows, porch rails, and vents under the house. The figure on the porch attracts the viewer's attention and brings life into the work.

Like most plantation houses, this one was painted green, with a rust-colored fungus growing on the wood—making an interesting color combination. You can see this above the windows in front, where I first painted the green and then dropped the red into the wet paint in vertical strokes, following the direction of the wooden boards.

13

Perspective Made Simple

It takes months to learn the mathematical formulas of linear perspective. But there is a way of approximating perspective that you can learn instantly. If you can tell time on a conventional clock, then you can draw in perspective. In reading the position of the clock's hands, you are using the same visual skills that an artist uses to sight an angle in perspective. It takes only a little practice to transfer this skill from telling time to painting.

To determine the proper angle of a figure, building, table, or some other object, mentally superimpose the image of a clock over the subject. In other words, when you look at the edge or line you want to draw, imagine that the line is one hand of a clock. Then ask yourself: What number on the clock would that hand point to?

Once you commit yourself to an angle in this way, the guesswork about perspective is gone.

Here are a few tips to keep in mind. First, if the "hand" points between two numbers—say, between 4 and 5—judge how much in between, and then record that angle. Try to be accurate down to the minute. Also take particular care in measuring when the angle is nearly vertical or nearly horizontal—accuracy is critical.

The "clock" method is almost foolproof—if you use it. One of the most common perspective mistakes students make is to draw the angle backward. But if you think about telling time, you can easily avoid or correct this kind of perspective problem. Always take a few seconds to check the angles in your drawing.

To determine the proper angle of an object in perspective, simply imagine a clock superimposed over the subject. In the example here, notice the different times for the top and bottom of the folding door. Check some of the other angles in this sketch, and then go on to experiment with the clock method in your own drawing.

14

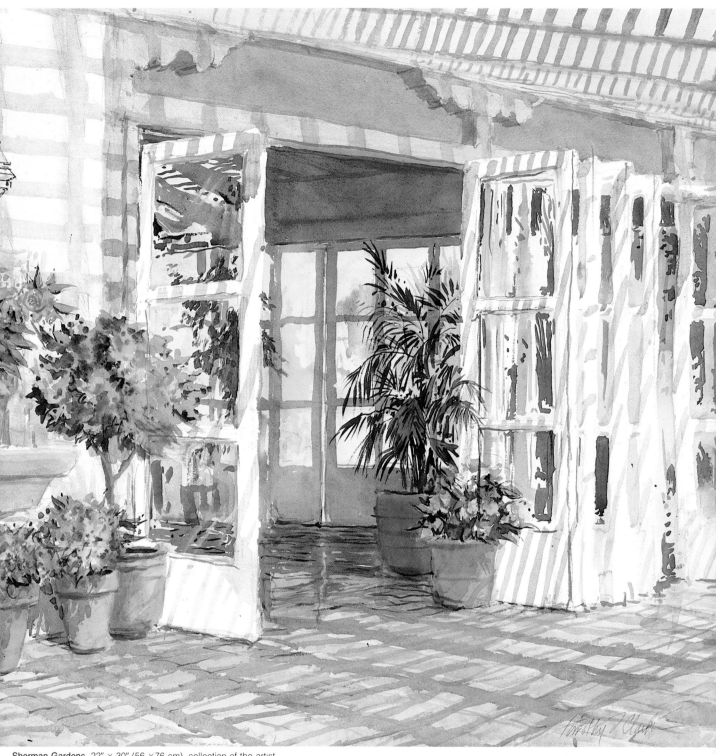

Sherman Gardens, 22″ × 30″ (56 × 76 cm), collection of the artist

A complicated architectural subject like this one, with its multiplicity of angles, requires careful drawing. In choosing this subject, I wanted to lead the viewer's eye in and around the scene, through various passages, and to convey the flickering quality of the light. I also wanted to play with the contrast between the plants and light patterns and the architecture itself. None of this would have been possible, however, if the drawing were faulty, distracting the viewer. For that reason, I used the clock method to check the angles of the roof, doors, tiles, and shadows.

15

Contour Drawing

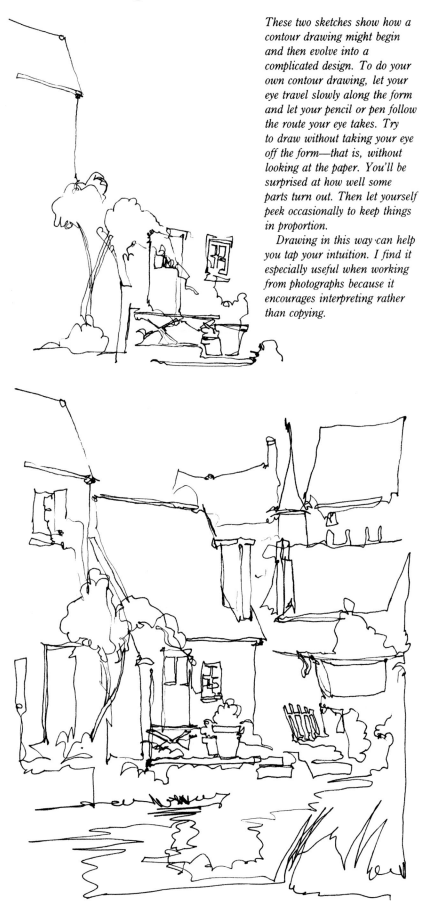

<p>*These two sketches show how a contour drawing might begin and then evolve into a complicated design. To do your own contour drawing, let your eye travel slowly along the form and let your pencil or pen follow the route your eye takes. Try to draw without taking your eye off the form—that is, without looking at the paper. You'll be surprised at how well some parts turn out. Then let yourself peek occasionally to keep things in proportion.*</p>

Drawing in this way·can help you tap your intuition. I find it especially useful when working from photographs because it encourages interpreting rather than copying.

A good way to develop an eye for line and shape is by contour drawing. There are two basic approaches to contour drawing. In pure contour drawing you look only at the subject—not at the paper—and allow your pencil or pen to follow what your eye sees, moving in a continuous line. Although the resulting drawing may well seem out-of-control, it will usually show some remarkable passages of keen observation and good design.

The second method of contour drawing is almost identical to the first—only this time you can peek to find your spot. It's usually best to try this method only after you've spent some time practicing pure contour drawing. That way you won't be tempted to peek so often and will be more willing to trust your eye-hand coordination.

Much has been written in recent years about the way contour drawing taps the subconscious. Some, however, argue for the role of consciousness in this process. I think that over the long haul you need to use both the subconscious and the conscious mind—your whole head!—to make effective drawings.

Doing a contour drawing takes some time, but the very process is packed with useful information—it forces you to really look at your subject. The concentration required makes it a good workhorse for the artist. In addition, the results can be surprising, with well-designed decorative shapes and an expressive quality to the line. You may then want to incorporate aspects of these shapes and lines into your painting.

The contour drawing familiarized me with the shapes in this scene and gave me a feel for the flowing line of the plant forms and the reflections in the foreground. This may sound lazy, but one of the things that made this scene such a joy to paint is that the white of the paper automatically painted almost half of the picture. After drawing and composing the scene, I spent most of my time articulating the planes and edges with subtle washes. I used only a few real darks, primarily to frame the lights and provide contrast.

Notice how the simple cottage holds its own against the castle in the distance. This is due in part to the energetic line in this area. The lively pattern of the reflections attracts our attention while the plants and cast shadows lead our eyes in and around the cottage itself.

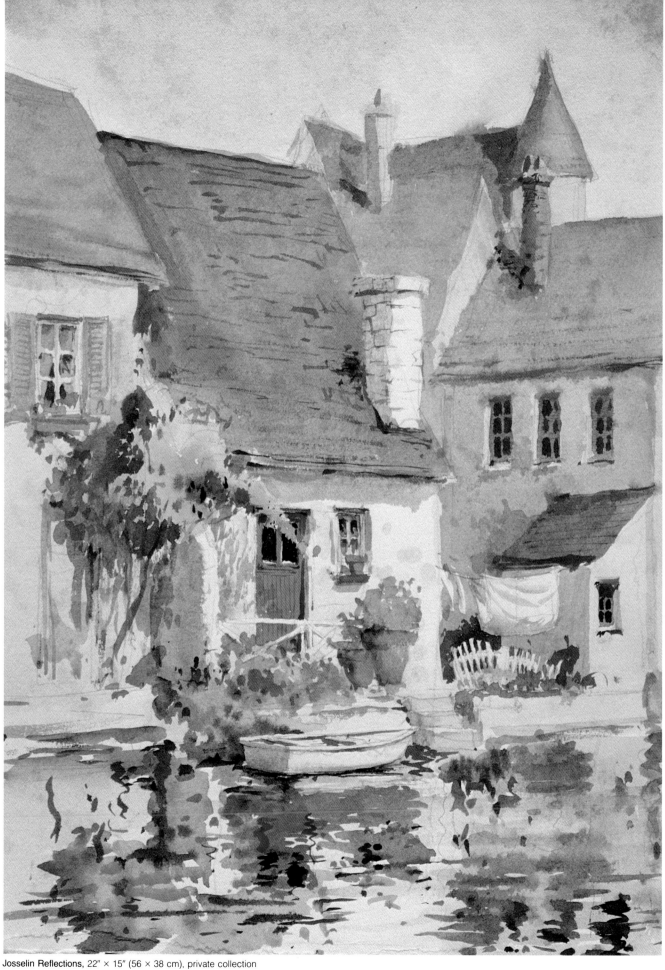

Josselin Reflections, 22″ × 15″ (56 × 38 cm), private collection

Drawing Sight-Size

An easy way to get proportions right is to draw everything sight-size—the same size that you see it. This technique can save beginners a lot of headaches, because you don't have to enlarge or decrease the image in your mind. Later, as you gain experience, you won't need to use this method as much—although it can come in handy when accurate proportions are imperative, especially in portraits.

Drawing sight-size ties in with the way we see things in perspective. When an object is close to us, it appears relatively large. If the same object is moved away, it appears smaller. When you draw sight-size, you are taking this into account. Thus, in your drawing, a plant in the foreground might be larger than a house in the distance—because this is how you see it.

To explore sight-size drawing, tilt your easel up so you can see the paper and the subject simultaneously. If you want to make the subject large, move close to it. Do the reverse for a smaller image. Once you have a clear mental image of how much you want to paint, imagine the subject on your paper, the same size as you see it from your vantage point. Now block in the shapes and refine them.

One useful "trick" is to put an X on the upper edge of the paper, on the line of sight between the subject on your paper and the subject in reality. If you stare at this X, you should be able to see the actual subject and your drawing simultaneously. That way it's easy to see if your drawing is the same size as the subject, or if you've made it too large or too small.

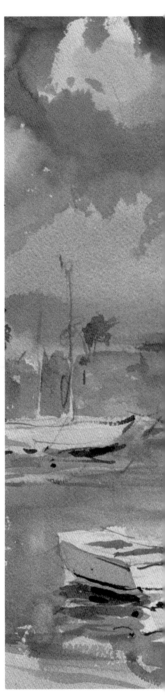

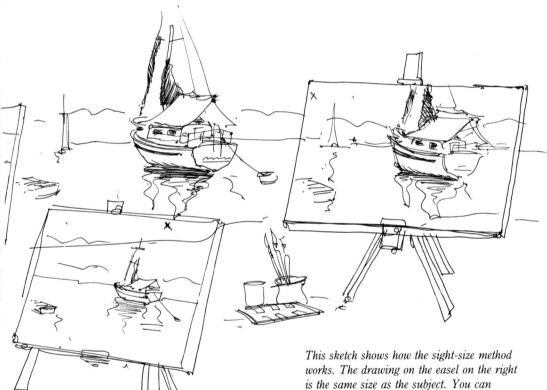

This sketch shows how the sight-size method works. The drawing on the easel on the right is the same size as the subject. You can double-check that the boats are the same size by staring at the X in the upper left corner of the picture.

In the other drawing, on the easel at the lower left, the image has been reduced compared to what is seen. The difference in size becomes readily apparent if you stare at the X at the top of the picture.

Of course, there is nothing wrong in making your drawing larger or smaller than what you see—it is just more difficult. When you are starting out, you want things to be as easy as possible, so try to draw the subject sight-size.

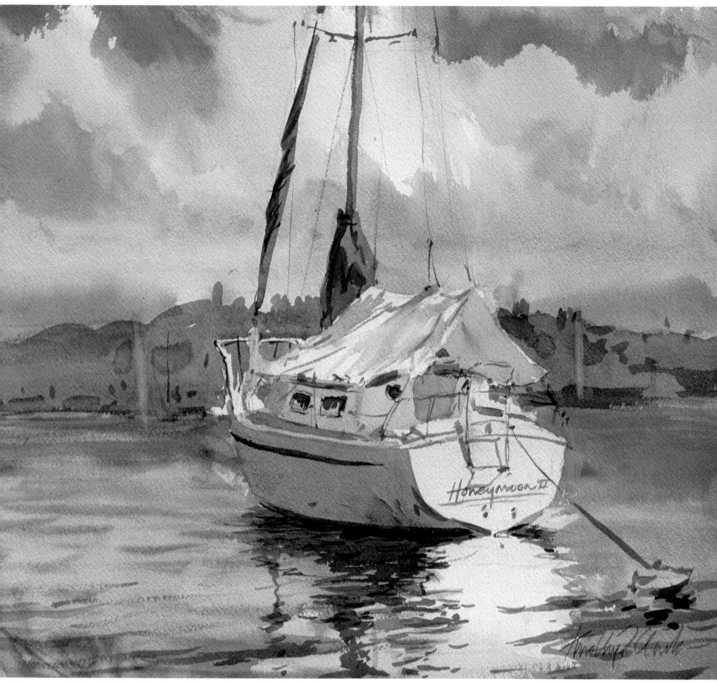

Honeymoon II, 15″ × 22″ (38 × 56 cm), collection of Don and Virginia Mead

Although I've used this scene to demonstrate the concept of sight-size, I cannot honestly remember if I did the actual painting sight-size. My point is more that sight-size was helpful to me in the beginning, and I hope it will get you started too. Today, however, I no longer think about sight-size and often change a size to fit my needs.

In painting this scene on location my main concern was capturing the quality of the light. I was taken by the way the light filtered through the white canopy and by the shimmering reflections in the water. To paint the water, I first put in the pink areas, reflecting the clouds, and then added the blue-green and purple reflections on top. The soft sails across the harbor were diffused by the distance. To achieve their almost ghostly light value, I wet the area and then removed the paint with a dry brush. The feeling of strong light breaking through the clouds to shine on the back of the boat comes from the white of the paper—in contrast to the darker, painted "colors" of white around it.

View of St. Marks, 15'' x 22'' (38 x 56 cm)

CHAPTER TWO

SKILLS FOR COMPLETE PALETTE CONTROL

The basic skills behind watercolor painting are relatively easy to learn—with a little practice. The place to start is with laying in a wash (see the next page). Don't worry about making mistakes. The important thing is to try. Often you can learn as much from your mistakes as from your successes.

As you explore painting flat, even washes and gradated washes on both dry and wet paper, you'll be learning how to control the flow of the paint. Of course, brushwork is also important, but that's something you may be more inclined to experiment with on your own (see pages 74–77 for some specific ideas). Keep in mind that one of the intrinsic beauties of watercolor is its transparency. Don't make your washes too thick, or you'll lose the sense of light that comes from the paper behind the wash.

In addition to mastering wash techniques, you need to understand three simple color concepts: hue, value, and intensity (see pages 24–29). There are probably almost as many ideas about color as there are artists, but if you focus on these basics you should be able to gain control over your palette, so that you can mix the color you want. At the same time learning about color is an ongoing process—every painting you do should teach you something new.

To understand the importance of the skills discussed in this chapter, you might think of a singer, who needs to be able to hit specific notes in a scale. If the singer can't hit the note in the scale, he or she won't be able to hit the note in a song. The same holds true in painting. If you can't mix a color or a value in an exercise, how do you expect to be able to mix it in a painting, when you're also concerned with drawing, composition, and expression? The goal is to make the basic skills second nature so you can concentrate on what's really important in painting—the idea or feeling you want to communicate.

How to Create Washes

Working with washes is one of the most basic watercolor skills, and you can master this technique in just a few tries. Let's begin with a flat wash, where you cover an area with one tone, without any variation in that tone. Choose a fairly large brush so you can use fewer strokes. Place your board at a slight angle so the paint runs downward, without puddling. Then, after mixing the color you want, load your brush with enough paint so the paint flows. Make a stroke and then reload your brush. Place your second stroke so that it slightly overlaps the first one. Continue this process, slightly overlapping each subsequent stroke, until you have covered the area you want. After the last stroke is complete, touch your brush to a towel to remove any excess paint. Then go back and pick up any excess drips with the tip of the brush.

To create a gradated wash—one that gets progressively lighter in value—you use the same process as for the flat wash, only this time you add more water to each stroke. Start with your darkest stroke. Then wipe off any excess paint and dip your brush into water for each successive stroke, ending with pure water or whatever value you desire. Be sure that your board is tilted up slightly, and remember to overlap your strokes.

Washes are usually practiced on dry paper. When painting, however, you may want to paint on wet, as well as dry, paper—working wet-into-wet. The results are very different. Dry paper allows you to work with a lot of control, creating hard edges and flat color. Wet paper, in contrast, is good for soft edges and variegated values. These two techniques are often played against each other in a painting. The best way to learn about their effective use is to experiment—even painting the same subject with different techniques.

For a gradated wash, paint a dark stroke. After wiping off any excess paint, continue by dipping your brush into water for each successive stroke, making the wash progressively lighter. Again, overlap your strokes.

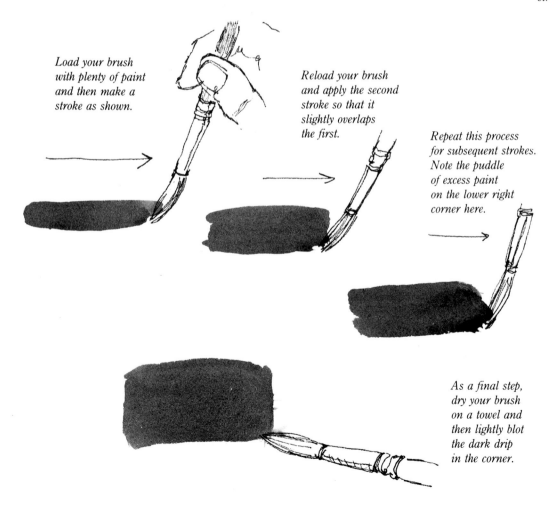

Load your brush with plenty of paint and then make a stroke as shown.

Reload your brush and apply the second stroke so that it slightly overlaps the first.

Repeat this process for subsequent strokes. Note the puddle of excess paint on the lower right corner here.

As a final step, dry your brush on a towel and then lightly blot the dark drip in the corner.

First, mix any color with enough water to make the paint flow and slowly move your brush across the paper. If you move too fast, the paint won't be able to flow into the grain of the paper. Now take a clean brush and wet the paper. Using the same color as before, brush across the wet area. Note the difference between the two strokes. Not only does wet paper make the edges softer, but it also gives you a lighter value.

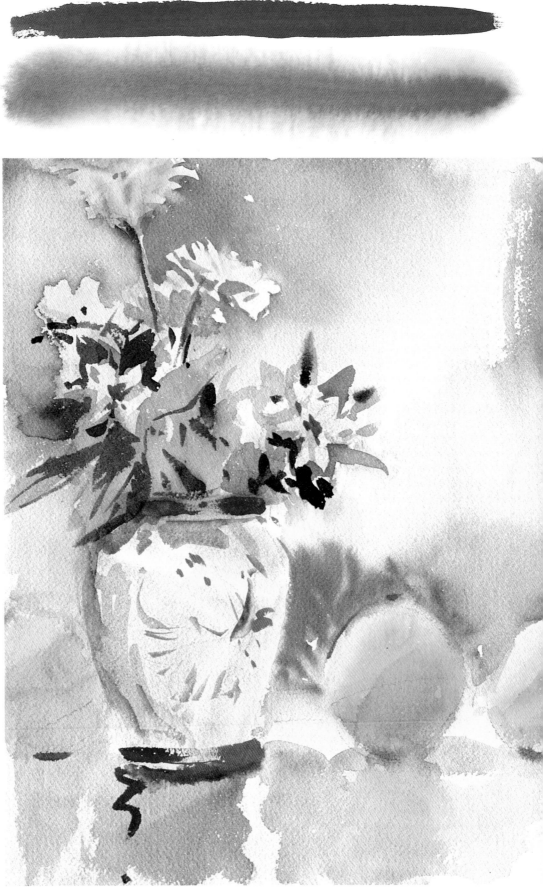

To create the variety of washes you see in this still life, I first wet the paper. By working wet-into-wet I got the soft, fuzzy edges that are so important to the mood of this painting. Then, as the painting dried, I added some harder edges, which help to clarify the forms. But you don't have to rely on hard edges to define forms. Notice how the dark grays in the background frame the lighter orange, emphasizing its shape.

Still Life, 12″ × 10″ (30 × 25 cm)

Painting a Value Scale

Value—the lightness or darkness of an area—is an important consideration in all drawing and painting. It can help you create the illusion of three-dimensionality and a feeling of space. It can also provide an enlivening contrast.

To learn about value, it is best to work first in black and white. A good place to start is with a value scale. Although often students are asked to paint ten steps, from white to black, I believe that eight values are more manageable and just as useful for teaching purposes.

Essentially, a value scale consists of a series of flat washes, progressing in even steps from light to dark. Begin with the white of the paper. Next mix a very light wash, using a lot of water with your paint. Then, as you paint subsequent washes, add more paint each time until your last wash is black.

To check the evenness of your steps, squint. If a value is off—too light or too dark—it will visually "group" with the nearest value, above or below it. The scale will then appear to have a break; it will not flow.

Don't despair if you don't get it right the first time. It takes practice to paint a value scale with ease. Spend a few minutes working on it before each painting session, and you will master it in no time. You might think of it as practicing a musical scale. In any case, it is an important skill to learn—if you can't hit the right value on a practice page, then you're unlikely to get what you want in a painting.

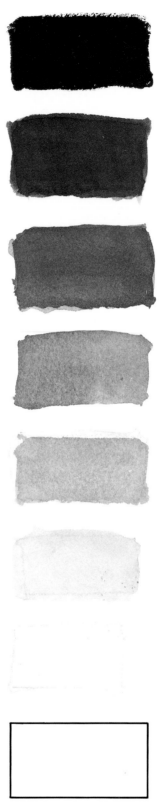

For this value scale I used black watercolor paint to get a full range of values. If you'd rather not use black, try alizarin crimson and phthalo green for neutral grays and a rich dark.

Developing Color Skills

To paint in watercolor—or any other medium—you must be able to work with color. One of the first steps is to understand the three basic properties of color—hue, value, and intensity—and how they affect vision. But understanding isn't enough; you need to practice and experiment to *see* how color works.

To begin, let's look at a color wheel. You probably already know the basic principle here: that the mixing of two primary colors (red, yellow, blue) gives you one of the secondary colors, shown in between (orange, green, violet). If you've never actually tried this, take some red, yellow, and blue and make your own color wheel.

Now let's consider hue. Hue is what we commonly think of as a color. Red, yellow, blue, green, violet, and orange are all names of hues.

Each hue has its own special properties. Study the color wheel for a moment and single out a hue. Let's take red. Which color is furthest away from it (opposite it) on the color wheel? Green. It is important to know this instinctively. To understand this point, stare at the center of the red square on page 25 for 30 seconds. Do not take your eyes away for even a moment. Then stare at the blank square for 20 seconds. Again, do not shift your gaze. What you'll see is a green square, and this negative after-image "proves" the concept of complementary color. Essentially, because red is the opposite of green, when you overdose on red, your eyes manufacture their own green to compensate.

Artists are aware of the special complementary relationship between red and green, blue and orange, and yellow and violet. Used appropriately, complementary colors can create a sense of balance in a painting. They can also produce exciting vibrations when played one next to the other.

This color wheel is made from purchased pigments, but you can also get the secondary colors (orange, green, and violet) by mixing two of the primary colors (red, yellow, and blue).

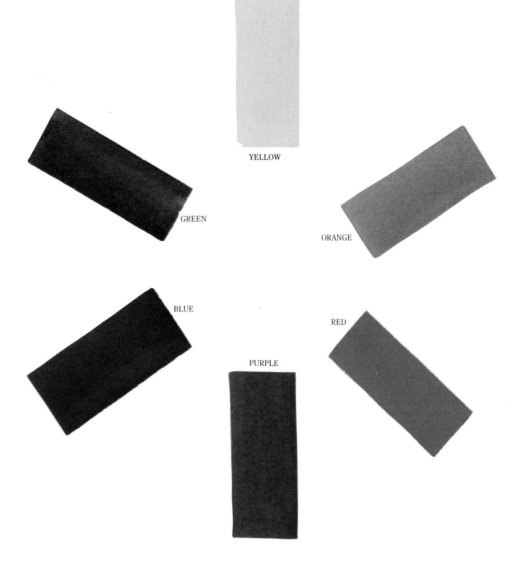

YELLOW

GREEN

ORANGE

BLUE

RED

PURPLE

Stare at the center of the red square for 30 seconds; then immediately afterward stare at the center of the white square for 20 seconds. The square should appear green. This negative after-image is the complement of red.

Determining Color Value

Color value defines how light or dark a hue is. The basic concept here is similar to what you have already learned in creating a value scale from white to black. The point to keep in mind is that each color has its own inherent value. In simple terms, yellow has a light value and royal blue has a dark value. Most of the other colors fall in the middle of the value scale.

To help you understand the relationship between value and color, try this exercise. First paint an eight-step value scale and then paint the various colors on your palette next to the gray they most nearly match. If you have difficulty seeing the value of a color, squint. As you do this exercise, you'll discover, for example, that it is impossible to obtain a very dark yellow (brown is a substitute at best). And you'll begin to deal with the limitations to the range of color values.

Another exercise involves altering the value of the manufactured color. You can lighten or darken the color you buy, thus expanding its range. Essentially, with watercolor, you add water to arrive at lighter values, and you add pigment to go darker. There's no problem getting light values, but often it is difficult to get the dark values. You may need to mix in another color to cover the full range of values.

Value is closely connected to the third property of color: intensity. As you work with values, you'll notice that the brightness of the color changes as its value changes. A dark red like alizarin crimson, for instance, is not at its brightest until you have diluted it a little, but as you continue to add water, making it lighter and lighter, it loses its intensity again. In general, the full-strength color is dark but not bright; when it's slightly diluted it's a middle value and bright; when it's greatly diluted it's light but not brilliant.

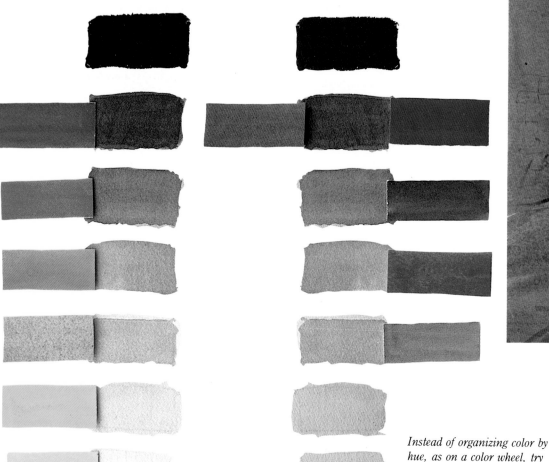

Instead of organizing color by hue, as on a color wheel, try organizing it by value, in comparison to the grays of a black-and-white value scale.

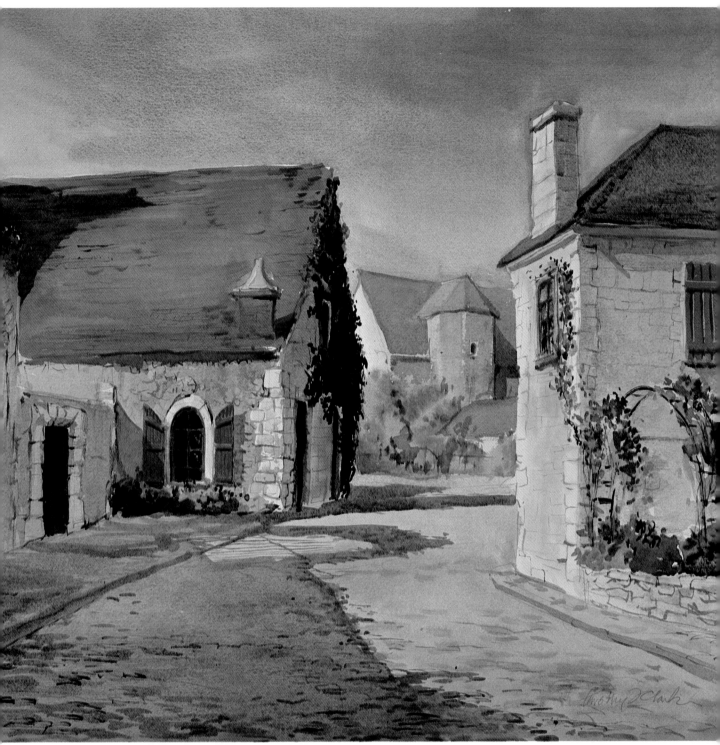

Village of Chenonceaux, 22″ × 30″ (56 × 76 cm), collection of Mr. and Mrs. M. Ball

If you paint in late afternoon light on a clear day, as I did here, your subject will have clear divisions of light and shadow. Notice how the roses climbing up the entranceway on the left move from dark hues in the shadows to bright lights in the sun. Then notice how, in the top right corner of this entranceway, the dark greens seem to almost merge in tonality with the shadow on the roof. Try to keep the value structure of your painting clear, even if the color changes.

Controlling Color Intensity

You've just observed what value does to color intensity. Just to set the record straight, intensity is the brightness or dullness (grayness) of a hue. "High intensity" refers to bright color, while "low intensity" designates grayed color.

A wonderful way to learn about controlling intensity and mixing color is to make an intensity scale. Simply use any complements: one on each end. Let's take red and green. Starting with red, first paint a pure red swatch; then paint a red that has a little green added to it —enough to make it less intense, but still clearly red in hue. Next mix red and green to get a neutral gray. Then neutralize your green with some red. Finally, paint a pure green.

It's a good idea to make a chart of all three complementary pairs: red-green, orange-blue, yellow-violet. This will familiarize you with both the pure color and slightly less intense versions—important knowledge for any painter.

This intensity scale is made by using complements to gray each other. The color in the middle of each column is a relatively neutral gray—the result of even mixtures of the two complements.

RED BLUE YELLOW

GREEN ORANGE PURPLE

If you overlap the intensity scales, forming a circle, you arrive back at the color wheel.

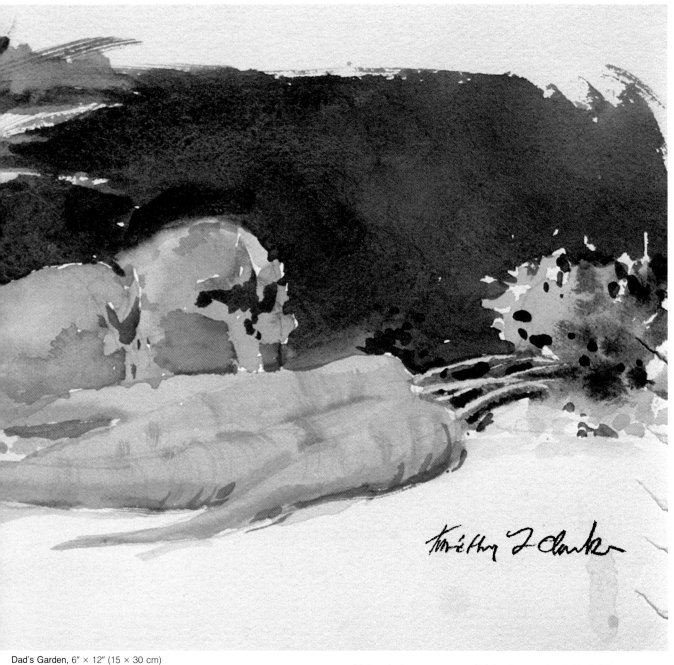

Dad's Garden, 6″ × 12″ (15 × 30 cm)

This painting may appear bright, but much of this brightness comes from comparison to the neutral areas. The painting actually weaves in and out of high and low intensity, playing one against the other.

Laying Out Your Palette and Mixing Color

After experimenting with different ways of laying out colors on my palette, I've found I prefer an arrangement that basically follows the color wheel. Starting in the upper left corner, moving toward the right, the colors progress from light yellow to warmer yellow to orange, various reds, and then violet. On the bottom row, the colors go from earthtones such as raw sienna and yellow ochre on the left, through yellow- and blue-greens, to various blues.

This arrangement is a good way to keep your color relatively pure without needing a great barrier to separate everything. If any color accidentally spills over into the adjacent color, no great damage is done. Sometimes I even like to have the colors merge together.

As I mix a color, I like to work with a spread of color. If, for example, I'm mixing yellow and red, I place a bright yellow opposite a bright red and then string the colors out so there's a gradual change from yellow to red. In other words, I give myself a variety of choices and try to pick the winner in terms of the needs of my painting.

As far as cleaning the palette, I use the corner of a rag or a paper towel to wipe off the mixing area. If I need to, I run it under the faucet. But I am not overly fastidious about cleaning after every brushstroke or every mixture. I do not think that is necessary by any means.

One aspect of color mixing that often sparks a twinge of fear in a student's heart is trying to match an existing color in a painting. Often it's difficult to remember the exact pigments and proportions that were used. But there's no reason to panic if the color doesn't match perfectly. Many artists like to include a range of analogous color to enliven their paintings.

If, however, the color must be absolutely on the button, then the only thing to do is to use identical pigments to those used before. It's even wise to use the same brand of paint. Also, be aware of the conditions under which you mix the color. If, for example, you mix a color outdoors to match a section of a painting, that color may not match your painting indoors. Or if you mix your colors under incandescent light and then put the painting under fluorescent light, chances are the patch will show. A point to remember here is to use a balanced palette, with a variety of warm and cool colors, so your painting will be interesting under any light.

One other point to bear in mind if you're trying to match an existing color: if the color looks right when it's wet, then it's wrong. That may sound like a contradiction, but you'll soon discover that watercolor dries lighter. Students often ask, "How much darker does the pigment have to be when it's wet?" or "How much lighter will it dry?" The degree of change will depend on how wet your paint is. If you add a lot of water to your paint, the value change will be considerable when the paint dries. Or, the more the paint puddles on the paper, the greater the change. The more, however, the paint is brushed into the paper, the closer it will dry to its value when wet (although it will almost always dry a bit lighter).

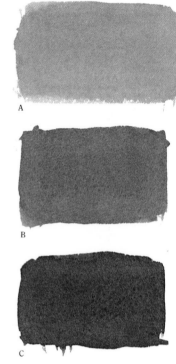

A

B

C

To match patch A with the proper value, the paint needs to be about as dark as B when wet. If the mixture has a lot of water in it, it may need to be as dark as C.

On my palette I keep a warm side and a cool side, with a small section for earth colors. In generally, the colors follow a color-wheel arrangement, so if one color spills into an adjoining section, there's not much color contamination.

Just as a baseball manager changes the players in the lineup, I change my colors regularly, adding and subtracting pigments. One day my light blue may be cerulean; another day, manganese blue. Or I may shift from cadmium yellow to new gamboge. I change colors depending on my mood and to avoid ruts. Greeting a new color, as well as an old friend, can be an exciting challenge.

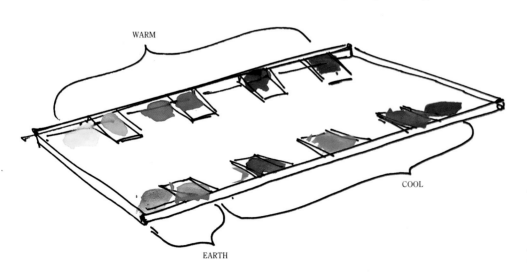

WARM

COOL

EARTH

When mixing colors, I like to string out a mixture as shown here and then pick the section that works best for me. I find this much easier than mixing a big puddle in the middle until it looks right. With a variety of mixtures in front of me, I can see the right color almost instantly, and it's easy to repeat.

This figure was painted rapidly, using fluid washes on dry paper for the flesh. To convey the silky quality of the robe, I wet that area first. The color, however, dried too light, so I had to restate the initial values. Later I added the crisp accents.

Some of my colors here were actually mixed on the page. In places, for example, I painted a warm gray over a cooler gray to arrive at yet another gray. This is similar to painting a blue over a yellow to get a green.

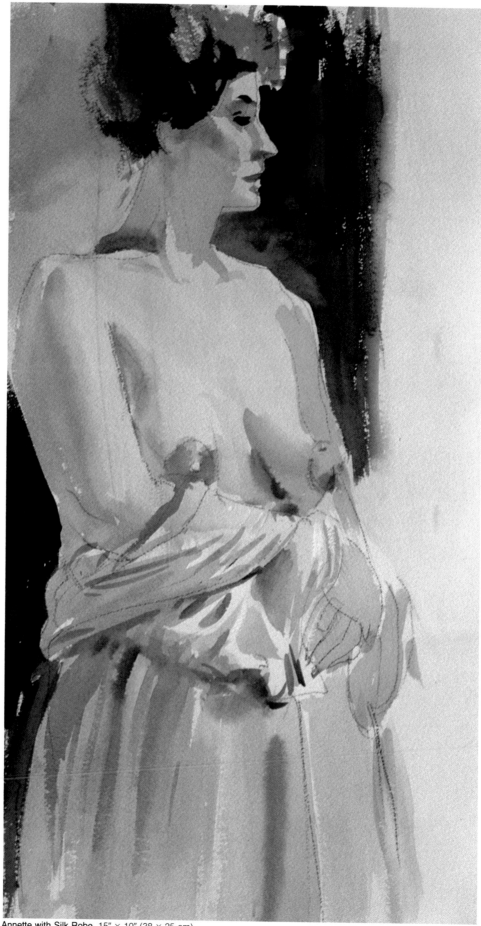

Annette with Silk Robe, 15″ × 10″ (38 × 25 cm)

Landseer's Studio, 15'' x 22'' (38 x 56 cm), collection of Mr. and Mrs. C. Newcomer

COMPOSING A WATERCOLOR

Painting without composition is like cooking without direction. Just because you like two foods individually—herring and ice cream, for example—doesn't mean they go well together. In a painting you can't just combine the elements willy-nilly; you need to take a few moments to plan your presentation.

Composition is often what distinguishes a great painting from an ordinary painting. Think, for example, of the tremendous sense of drama in Rembrandt's paintings. This drama is a result of composition, of the way the lights are arranged on the painting surface. Or—for a more modern example—look at a painting by Henri Matisse. It isn't only the color that gives his paintings power, but also the way the shapes are arranged.

The idea here is to stop and think before you paint. Don't just copy what you see in front of you; organize it in a way that will express your response to it. Begin to edit what you see, making decisions about what's important and what's not. You shouldn't be afraid that composing will ruin your spontaneity. I like to think of a story I read about Winston Churchill (who happened to be a fine amateur painter as well as an important statesman). Once he was caught practicing an "ad lib" comment on some parliamentary issue in front of a mirror. You, too, might practice your "ad lib" watercolor statements, composing them into stronger paintings.

As you read through the different ideas in this chapter, however, you may feel overwhelmed. How can you remember all these things at once? Don't panic. Take the lessons one at a time, and each time try to incorporate what you have learned into a painting of your own. Also spend some time just looking at great paintings and ask yourself what makes those compositions work. The more you think about composition, the more it will become part of the way you see—almost instinctive.

Repeating Shapes for Unity

Creating a theme of repeating shapes is one of the oldest compositional ideas, easily dating back to the Assyrians. One way of doing this is to take the shape of the main object and then repeat variations of this shape in other parts of the painting. What the repetition does is to help unify the work. It reduces the types of graphic information the viewer must decode and makes a design of the subject.

Although themes of repeating shapes can be generated subconsciously, there is usually some deliberate thought involved. Think of a poet rhyming words or of a music composer creating variations on a theme. Now try to imagine a poet achieving rhyme without some conscious effort. The artist also puts some thought into rhyming the shapes in a painting.

When analyzing a subject—a figure, for example—you'll see that within the form there are many subshapes. While maintaining the form, you might emphasize selected shapes that have elements in common—maybe straight lines on one side, curves on the other; maybe only triangles, or only shapes that tilt to one side. Usually artists work with simple geometric shapes, but it's also possible to use an intriguing complicated shape and then repeat that shape in a painting quite successfully.

I think it is easiest to control the shapes if you work from life, interpreting the subject directly. All too often artists who trace or use a projector uncreatively copy each area of the painting, and this can lead to a confusing number of individual shapes. Instead, the idea is to design and control a family of similar shapes, avoiding confusion. As you become more familiar with this concept, you'll find that when you're working directly with the subject, interacting with it, you actually see repetitions and relationships in the shapes in front of you.

This painting was completed in a few hours on the beach in Sorrento, Italy. There was plenty of action: fishermen, boats, buildings, and laundry flapping in the breeze. To organize the shapes, I created a theme using a variation of a triangle, almost an inverted keystone (see the diagram). This shape occurs in the cabin in the center and in the steep hillside on the right. Many of the individual pieces of laundry repeat this shape, and it can also be found in the grouping of figures and boats. Notice how this shape occurs in the space between the boats on the right. Also notice how some of the boat hulls suggest this shape turned upside down.

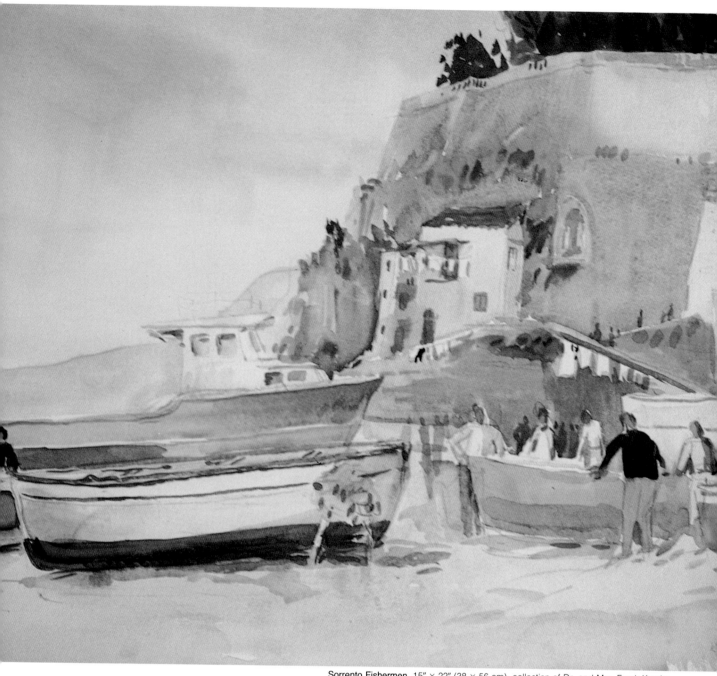

Sorrento Fishermen, 15" × 22" (38 × 56 cm), collection of Dr. and Mrs. Frank Kreske

Repeating Shapes for Unity

As I studied this hothouse before painting it, I was reminded of the design tradition of the Dutch painter Piet Mondrian. The white frames, windows, and gray interior rafters form a series of rectangular shapes, ordering the scene. Notice how these rectangles play against each other, varying in size and emphasis. Also notice how the doorway provides a frame within the picture frame and how the receding rectangles enhance the illusion of depth.

A second theme in this painting can be found in the pots with their sprays of foliage. Here, too, there are variations in size and in the relationships among the pots, so the repetition is never boring. The casual character of the pots helps to lighten the formal structure of the rectangles, keeping it from becoming rigid. In a sense the pots provide a counterpoint to the rectangles as they gracefully lead the eye through the picture.

One reason I enjoy painting this type of subject is that the combination of manmade pots, horizontal and vertical architecture, and natural orchids makes for an interesting design. There is, however, a danger, as it is all too easy to turn a painting like this into a study of greens. To avoid that here, I tried to take advantage of the red pots and tile floor and to emphasize the splashy yellow and violet blooms.

Pat's Hothouse, 20″ × 12″ (51 × 30 cm), private collection

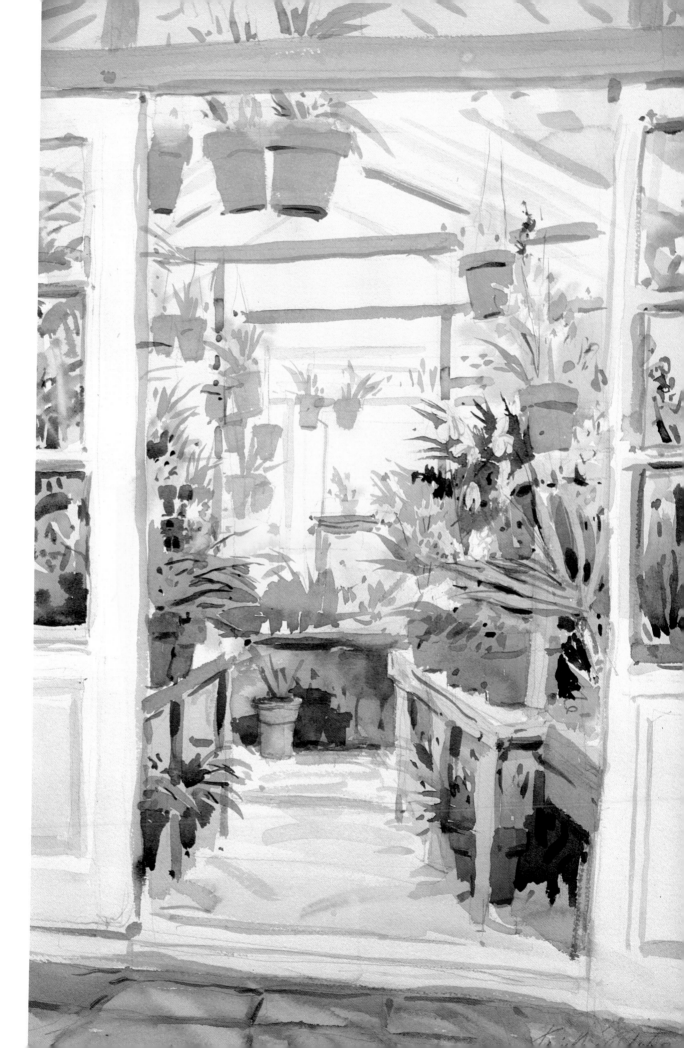

October Morning, 15″ × 22″ (38 × 56 cm), private collection

The areas of light and shadow reflected in the water were what caught my eye in this scene. It was a bonus that the shapes of the boats formed an exciting pattern (see the diagram).

I let the purple in the sky set the direction for the rest of the color. For the water, I first laid in a light purple wash, followed by a blue and then a darker purple wash—although I let some of the original light purple show through. If you compare these three colors in the lower right with the sky, you will see how accurately the water reflects the sky.

After establishing the lights on the boats, I dropped the darker shadows and reflections into the water. Finally, I painted some dark details on the boat in front, as well as on the simple background buildings. I did, however, use a bit of Maskoid (see page 86) to save a few thin whites on the front boat.

Now look at the diagram to see how the water reflects and repeats the shapes of the boats, creating a butterfly-like pattern. The picture as a whole provides a good example of a family of shapes. The hull of each boat is slightly different, yet they are enough alike to create a rhyme of sorts. You might think of the hulls as brothers and sisters. The subtle variations in the reflected shapes then continue to show family resemblances.

Designing a subject like this is relatively easy if you are alert to the possibilities. Here I carried the theme of the hull shape across the page. The shapes of the distant buildings provide some change, while still complementing the pointed hull. Finding ways to accentuate similar shapes is much more rewarding than fighting competing shapes that are not from the same family.

Interlocking Shapes

As we just learned, one way to make shapes relate is to "force" them to be alike, creating a feeling of repetition. Another way to establish relationships, while allowing for the individual character of the shapes, is to use interlocking shapes.

Think of the way railroad cars are coupled together or of how two hands join together in a handshake. Shapes can be interlocked in much the same way. If you can discover ways to make your shapes interlock, your painting will work as a single force, instead of being torn apart by fighting prima donnas.

The idea is to have one shape enter into the "territory" of another shape, so they fit together. Not only does this promote a sense of unity, but it also keeps the viewer's eye moving. And it adds to the graphic impact of the image—the two shapes become more than individual elements in a painting; they combine to form a design.

This is a very clear example of interlocking shapes. The bridge arches across the page and begins to embrace the gondola on the left. This interlocking structure then holds the painting together.

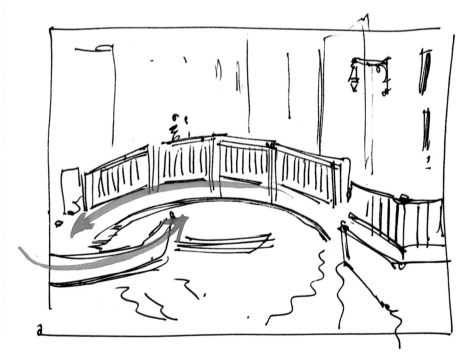

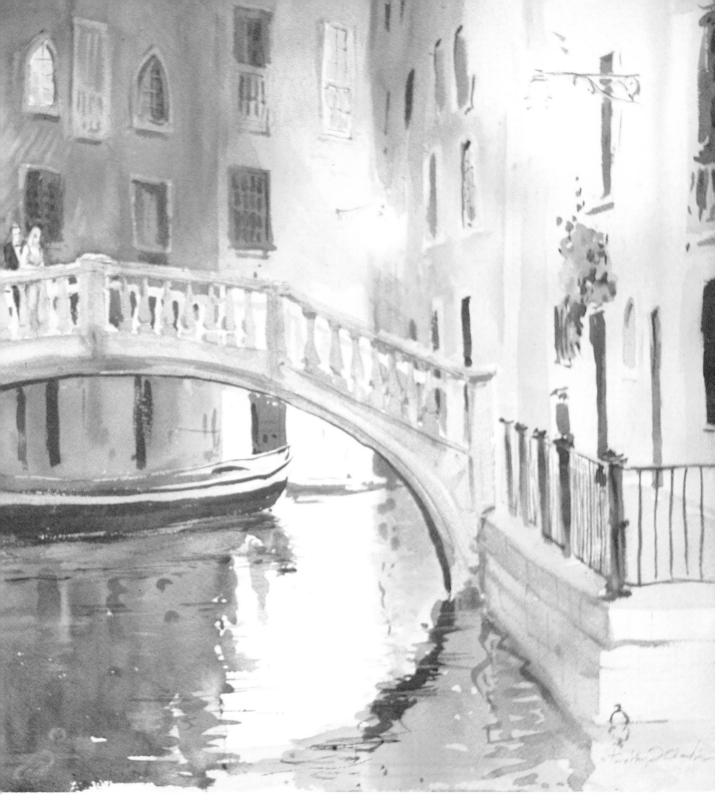

Bridge to Opera, Venice, 15″ × 20″ (38 × 51 cm), private collection

Venice is always romantic, but at dusk there is a special sense of mystery and drama. The street lights illuminate the sidewalks and reflect in the canals, providing both backlighting and front lighting. But there are also some areas, especially in the water, that remain dark and mysterious, suggesting intrigue.

With a strong sense of structure given by the interlocking shapes (see the diagram), I concentrated on the play of light and dark. Note that, although the bridge itself changes only a little in value from right to left, the buildings behind it undergo major changes. On the right the backlighting allows near-white light to come through, while on the left there are near-black darks peeking through the pillars of the bridge. The overall effect is a staccato pattern with darks and lights moving up and down and across the bridge. The resulting rhythm then helps to animate the painting without interfering with the movement of the interlocking shapes.

Dividing the Painting Surface

The root of all composition lies in breaking up the painting surface in an interesting way. If you divide the surface in an appropriate way, you might be able to skip some of the other, more complicated ideas regarding composition and still wind up with a well-composed painting.

Although there are many different ways of breaking up the rectangle of the paper you are working on, I see these divisions as falling into two general categories: the formal, static composition and the dynamic composition. A static arrangement uses equal sections, as in the illustration of the Taj Mahal, where the page is divided in the middle. Usually a strong key shape is necessary to sustain interest. Because this kind of spacing can be flat and boring, use it only with caution.

The dynamic composition plays long against short, or big areas against small areas. One example of this is the golden section, a way of dividing space that dates from ancient times. This mathematical formula states that the smaller is to the larger as the larger is to the whole, so there is a harmonious relationship between the parts and the whole. In practical terms, this means that you might place an area approximately three units long next to an area approximately two units long (see page 44). This proportion— sometimes called the divine proportion— was the basis for the division of space in all architecture, sculpture, and painting during the height of Greek culture; it was also used during the Renaissance and subsequent neoclassical eras.

I prefer to use a simpler, more flexible variant of the golden section: a square within a rectangle. For an example, look at my painting on page 45, where the rectangular page is divided into a square and a new rectangle. This arrangement has the potential for several subreadings, as the new rectangle and square can be broken again and again.

It may be encouraging to note that there is no such thing as a bad way of breaking up the surface, although some spacing relationships may not suit the artist's needs. If, for example, you want to convey excitement and drama and you develop a formal, quiet composition, it just isn't appropriate. The formal composition is not without merit, but it must be used at the right time.

Once you come to a good understanding of these theories, you'll be able to temper them with what looks "right." Although during certain periods of art history all artists followed the same format, I find that too confining. It does not allow me enough creative leeway.

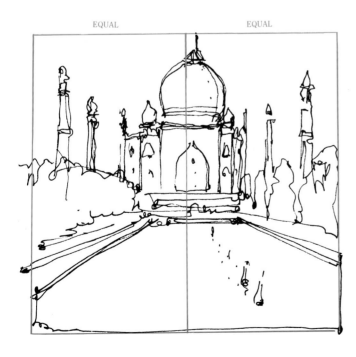

EQUAL EQUAL

This sketch of the Taj Mahal is an example of a formal composition, in which the painting surface is divided into two equal sections. Here the strong shape of the building holds our interest, but artists are usually very selective in the use of this kind of spacing because it can be monotonous.

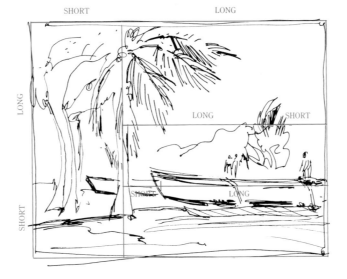

In this composition the palm tree divides the page into a short rectangle and a long square. This long-short relationship is continued in the placement of the horizon line and the spacing of the objects within the composition.

Storm over Kona, 18″ × 25″ (46 × 64 cm), collection of Jeff DuCharme

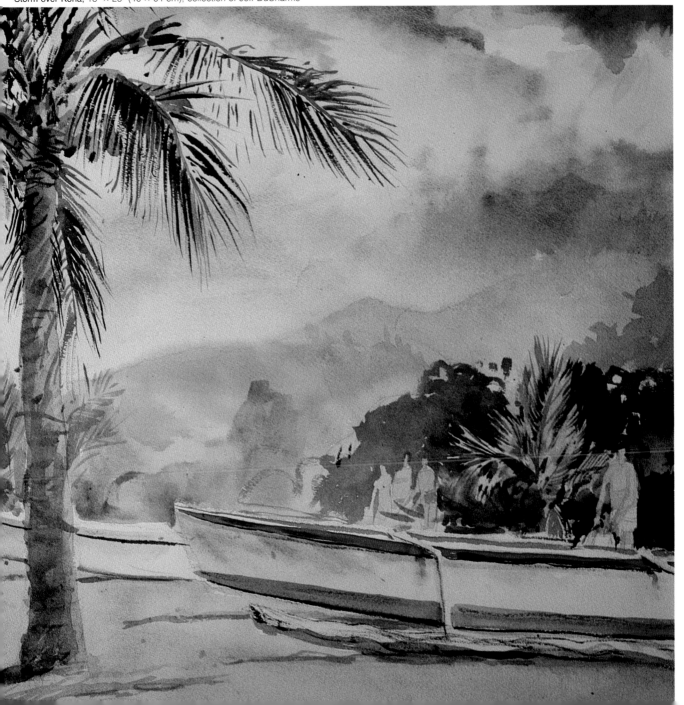

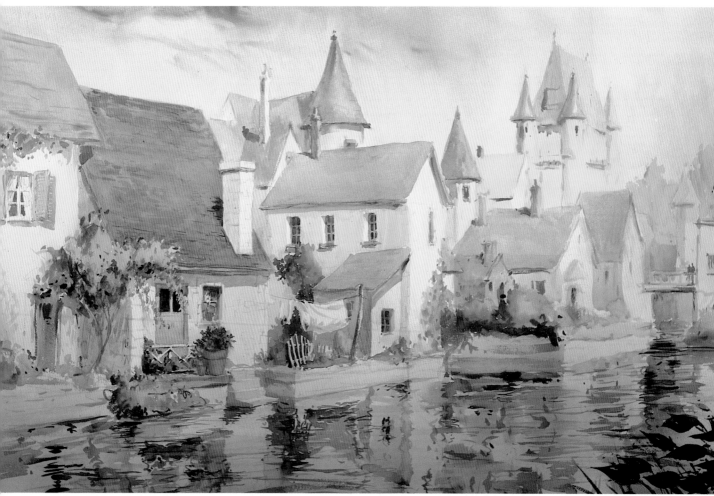

Sur la Mer, 25½″ × 40″ (66 × 102 cm), collection of Dr. and Mrs. Joseph Hart

This painting was developed from the golden section, dividing the surface into sections of two units and three units. These segments can then be further subdivided into smaller golden sections. This compositional arrangement carries an implicit feeling of harmony and balance.

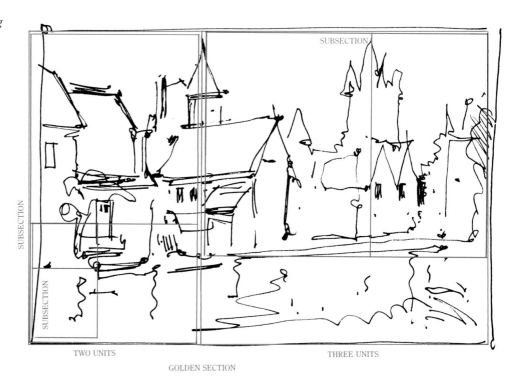

SUBSECTION

SUBSECTION

SUBSECTION

TWO UNITS

THREE UNITS

GOLDEN SECTION

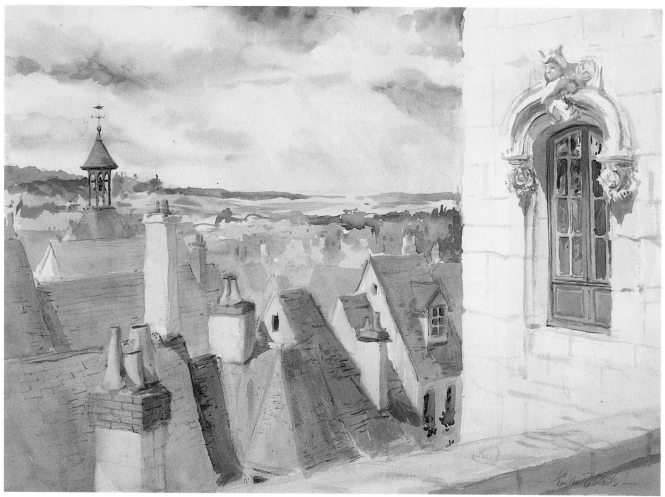

Overlooking Loire, 22" × 30" (56 × 76 cm), collection of Mr. and Mrs. Roger Curtis

The division into a square and a rectangle is very obvious in this painting. In addition to breaking up the painting surface, this division separates the foreground architecture from the deep space on the left.

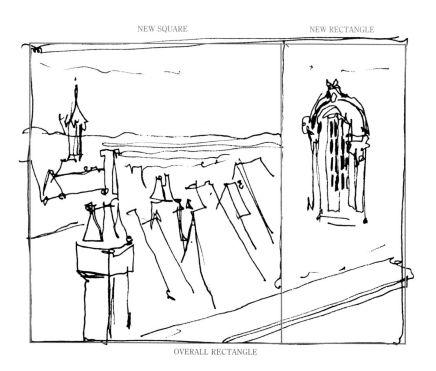

NEW SQUARE NEW RECTANGLE

OVERALL RECTANGLE

Designing Planes

Years ago I learned that it is usually a waste of time to paint without compositional direction. One of the simplest ways to compose is to reduce the subject to a large, interesting plane. The buildings along a winding street, for example, may be structured as a large, curved plane, as if a flat sheet covered the buildings. To think in these terms adds a subplot to the painting.

Sometimes I reduce the main concept to an imaginary piece of paper folded to follow the simple contour of the main form. The result may be an accordian-type fold, as in the second example here, or an interesting curve. The idea behind all this is to find a separate design element that works in an integrated manner with the subject.

I once knew a painter who worked abstractly, using only simple graphic concepts like these. His paintings had a minimum of elements, but there was always a strong design. I was inspired by this, but I like to add a second level of interest—the subject of the painting. To combine a realistic subject with an abstract design is the challenge for today's painter.

The simple curved planes shown in the diagram could be the basis of an abstract or a realistic painting. In Brittany Morning *they form a street curving back into perspective, which organizes the painting into something more than a series of doors, windows, and buildings. The light on the large curved plane on the left and the shadow on the smaller curved plane on the right create an alluring image of receding space. The long shadow stretching across the paper and climbing the wall on the left connects the two sides of the street. This is reinforced by the streetlight casting a shadow on the building.*

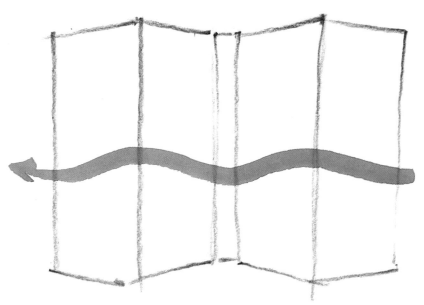

Instead of a curved plane, the doors in the second painting here resemble an accordion or a folded piece of paper, with a series of planes at different angles. The two posts and two sets of doors tend to set up a quiet, formal composition. Note, however, that the spacing of the two posts in relation to the paper's edges divides the page into small, medium, and large sections, defusing the static feeling of two objects. Also note the dominance of the doors on the left, which are more open and have a warm, dark accent. They not only attract our eyes, but also convey a sense of depth.

In the reflection on the lower right door, you can see my drawing board, easel, head and shoulder, and—sitting just below me—my daughter in a blue striped dress. I was broadly painting light and dark washes in the window when I noticed this self-portrait with my daughter painting next to me. Although painting reflections in a window may seem confusing, if you let go, the results may be better than you expect.

Brittany Morning, 22″ × 30″ (56 × 76 cm), private collection

Reflections, 22″ × 30″ (56 × 76 cm), collection of Mr. and Mrs. John Machuga

Suggesting Space

Dividing the picture space into foreground, middle ground, and background organizes the painting into levels of depth. This arrangement, which is the cornerstone of most landscape painting, builds on two natural phenomena: the effects of atmosphere and the mechanics of vision.

You've probably observed how dust, smoke, and moisture in the air make objects seem hazier and more diffuse as they recede in space. This effect is often called *atmospheric perspective*. But objects may also become fuzzy because of physical limitations in the way our vision works. When the human eye is focused on one subject or area, other areas or distances in the field of vision blur. If, for example, you focus on a flower in the foreground, it will be difficult to see the distant trees clearly, without shifting your focus. The term *depth of field* refers to the distance at which objects are still sharp.

The more you understand about atmospheric perspective and depth of field, the more effectively you will be able to organize and compose a scene into foreground, middle ground, and background. You'll find, for instance, that because the foreground consists of objects close to the viewer, it is usually—although by no means always—rendered with the most contrast. This area lends itself to crisp brushstrokes and the textural markings from drybrush techniques (see page 77).

The middle ground, on the other hand, tends to be "in between," with moderate to wide ranges of color, contrast, and technique. The center of interest is often located in this area.

In the background, at the greatest distance from the viewer, objects tend to have low contrast and low color intensity, as well as soft edges. But there are exceptions, such as a landscape at sunset or a theater interior. Backgrounds lend themselves to wet-into-wet techniques and silhouettes. You might experiment with painting the background as if it were viewed through a veil or fog or tissue paper.

After organizing the painting into foreground, middle ground, and background, the artist usually decides to let one of the areas dominate. Any one of the three areas can become the center of interest, although most often it's the middle ground or foreground, not the background. The reason most artists choose a particular area for emphasis is that if all three areas are equal, the painting may seem chaotic. This does not mean that each cannot be interesting; on the contrary, each area should be intriguing, without competing graphically.

The concepts of foreground, middle ground, and background fit into the established idea that a painting is a portable window for the viewer to look into. In the twentieth century this idea has been increasingly challenged by the claim that paintings are "objects"—paint on paper or canvas. From this point of view, illusion is a secondary consideration, much less important than the abstract arrangement of materials. But it isn't necessary to stand in one camp or the other; you can borrow from both. I find that combining the idea of composing space with an awareness of the materiality of the paint and paper aids the creative act. The Impressionists were early practitioners of this idea. While they recorded their observations of nature, painting what they *saw*, their thick brushstrokes "admitted" that their canvases were paintings, not reality.

The concept of the painting as an object may affect how an artist presents his or her work. Some watercolorists choose to float their paintings instead of putting a mat over the edge. If the content of the painting goes beyond a mere copying of nature, floating the painting will promote recognition of the painting as both an object and an illusion.

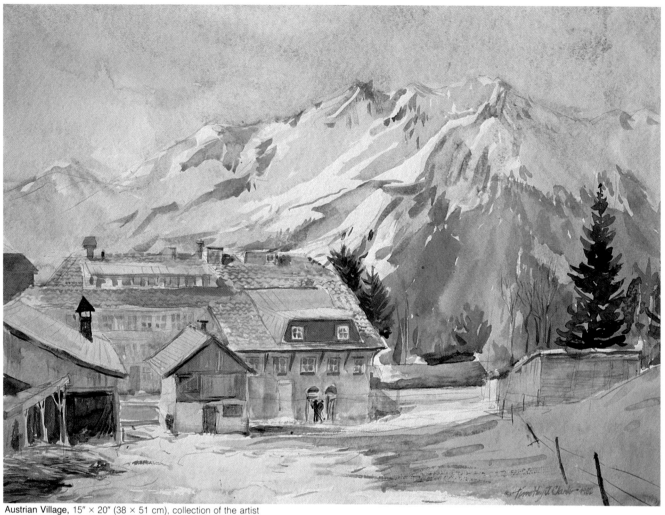

Austrian Village, 15" × 20" (38 × 51 cm), collection of the artist

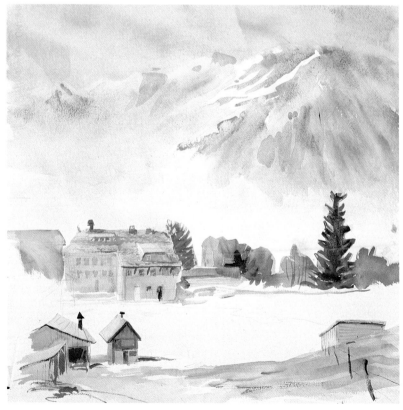

In this diagram I've separated the foreground, middle ground, and background so you can see the differences. For the most part the background is painted freely with the wet-into-wet technique. The colors are somewhat muted, and the values have a very narrow range, with no real darks. All this gives a feeling of soft focus, of looking into the distance.

The middle ground has a moderate range of color. The value of the building here is close to the value of the background, but the pattern of the roof tiles brings it forward and separates it from the background. Notice how the dark base of the tree on the right accents the foreground shed in the actual painting.

The foreground has several extra-strong contrasts, as in the chimney on the left or the tree and shed on the right (just mentioned). Notice the warm yellow accent on the hill on the right, which invites the eye into the painting. Also notice the use of drybrush on the gathered sticks on the left.

Overlapping Shapes

We've already touched on the concept of overlapping shapes in discussing foreground, middle ground, and background. But it's worth taking a look at this concept on its own, as a way of defining space. In everyday vision, when one object is directly in front of another, it partially or fully blocks the object behind it. This layering of objects is part of the reality of the way we see, and it can be used effectively by the artist to create an illusion of depth.

All too often beginning artists avoid overlapping shapes, painting each object in isolation. Some students paint objects as if they were viewing everything from a helicopter, looking down. Although this perspective can be interesting, it should be used judiciously—not as an excuse to avoid overlapping objects. Other students may paint objects from a normal perspective, but they become afraid to let the various elements interact. A common mistake is to place all the objects in the distance high on the page and all the objects that are close low on the page, even though the objects are actually seen as overlapping. In this case there is a perspective of sorts, but the disconnected shapes compete for attention and the overall effect is usually uninteresting.

The lesson of overlapping shapes is a simple one, but it can make a world of difference in your painting. Just look around the room you're in now. Notice how the way objects overlap tells you about their location in space. The same device used in a painting will help the viewer "read" the space.

Chambord, Castle and Village, 20″ × 25½″ (51 × 66 cm), collection of Roger and Lisa Curtis

This painting shows how overlapping shapes can reinforce the definition of foreground, middle ground, and background. Let's start with the flowers in the lower left corner. They overlap not only the road, but also the house, trees, and fence in the middle ground. Now look at the lower right corner. There a partially collapsed fence leads us into the painting, overlapping the white house, as well as itself. Because of the alcove on the left side, the front of the house overlaps the rear. Also notice above how the roof overlaps the dark green tree and how this ensemble overlaps the background.

Returning to the left middle ground, there is a succession of overlapping elements. In front there is a small tree, just beginning to bud. Next comes a fence. Then, behind the fence, is a small half-timbered building, which sits in front of the twin-dormered house, which in turn sits in front of the dark slate-roofed house on the far left. Even further back is a spindly tree and some evergreens.

Everything in the foreground and middle ground, on both the right and the left, frames and overlaps the castle in the background. Shrouded by a grayish golden mist, the castle is so muted that it is almost not seen for a moment against the much stronger contrasts of the foreground. But, on a second glance, you are invited to explore the little windows, chimneys, and towers. Even though this area is quite subdued in color and value, there is plenty to entertain.

For a final area of overlap, notice the clouds passing behind the castle towers. Also notice how the golden wash that I used across the castle and the sky makes the whites of the foreground stand out.

I can easily count more than twenty overlapping shapes in this painting. In addition to fostering the illusion of space, this overlapping helps to relate the shapes to each other.

Using Rhythm

There is much confusion about the term *rhythm*. Because rhythm deals with movement, you must first understand the two different kinds of movement in a painting. One kind is implied movement, when you illustrate something in motion, such as a horse jumping over a fence. The other kind of movement is eye movement—the direction the viewer's eye travels while looking at the painting. Here the subject itself can be static or moving—the movement occurs in the composition, which determines how we view or "read" the painting.

Rhythm is related to the second kind of movement: eye movement. It makes use of three basic principles: (1) repetition, (2) staggered accents, and (3) direction. The letter *S* is a good example of a simple rhythmic statement.

To clarify what I mean by rhythm, let's explore some possibilities for rhythm, starting with a circle (see the diagrams). By itself the circle has no rhythm. Our eyes go all around the circle and cannot move on to other parts of the painting.

Now let's divide the circle into two halves and shift these halves, as in the second diagram, so our eyes do a dance. We start by following the curve of the circle, but then, because the circle is incomplete, we jump to the staggered half. Our eyes no longer just go around but also move up, down, and across.

Look at the third diagram, in which several half-circles are teamed together to carry our eyes over a large area. We follow the curve on the first half-circle, then pick up the next half-circle, which carries us to the next, and on and on. This setup can effectively move the viewer from one part of a painting to another.

The problem that now arises is: How do we stop? Easy—just put a complete circle at the end (see the last diagram). When we come to this end circle, our eyes travel completely around it. You may even want to frame the center of interest with this kind of circular shape.

These examples are meant simply to get you started in exploring different kinds of rhythm. Instead of a circle, you may want to use a more complicated bracket-like shape. Muscles, fruit, boats—practically anything can be arranged to create a rhythmic statement.

With a circular arrangement, the eye keeps going around and around.

When two half-circles are staggered, the eye movement becomes more dynamic and interesting.

You can create a path of half-circles, leading the eye up, down, or across the composition.

To "stop" the eye, you might place a circle at the end of the path.

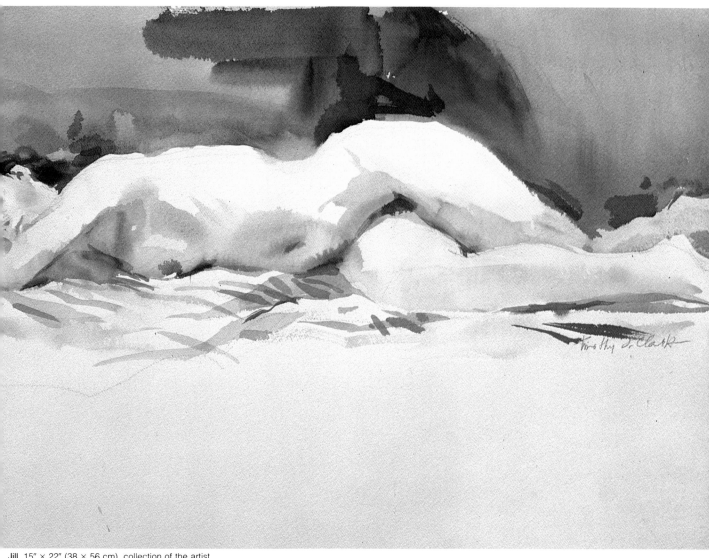

Jill, 15″ × 22″ (38 × 56 cm), collection of the artist

Notice how the circular shapes in this painting move our eyes across the paper. Starting with the model's left shin and the two dark accents under it, our eyes are led to the top of the hip, down to the abdomen, up to the back, down to the breast, up again to the shoulder, and finally to the face, which is framed by the dark hair.

The placement of darks and lights is carefully thought out to augment this rhythm. Take a look at the dark shape over the model's

hips, which accents their form. Compare this to the area above the small of the back, which has been lightened and treated with soft edges. This area is not part of the rhythmic statement, so it has not been accented.

This sketch, by the way, was painted in just under an hour one evening. Jill's poses always look relaxed, yet they have a dynamic, twisting quality that makes it easy to create a feeling of rhythm.

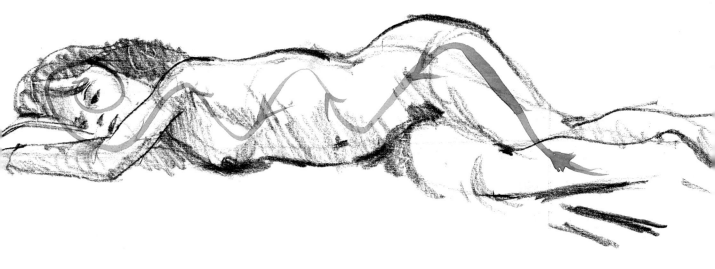

Using Rhythm

*Although the overall composition of this painting
makes use of a triangular shape, within this
shape the individual forms produce a different
rhythmic statement. The red line and arrows in
the diagram show how the forms were accented to
lead the eye into and around the fruit. The
circular shape of the basket at the end then spins
the eye around and holds the viewer's attention.*

*Again, notice how the lights and darks enhance
the eye movement. Darkening the space behind
the fruit, especially on the far left and inside the
basket, helped to reinforce the feeling of alter-
nating lights and darks, moving in and out.
In addition, the way the forms overlap enhances
the feeling of rhythm.*

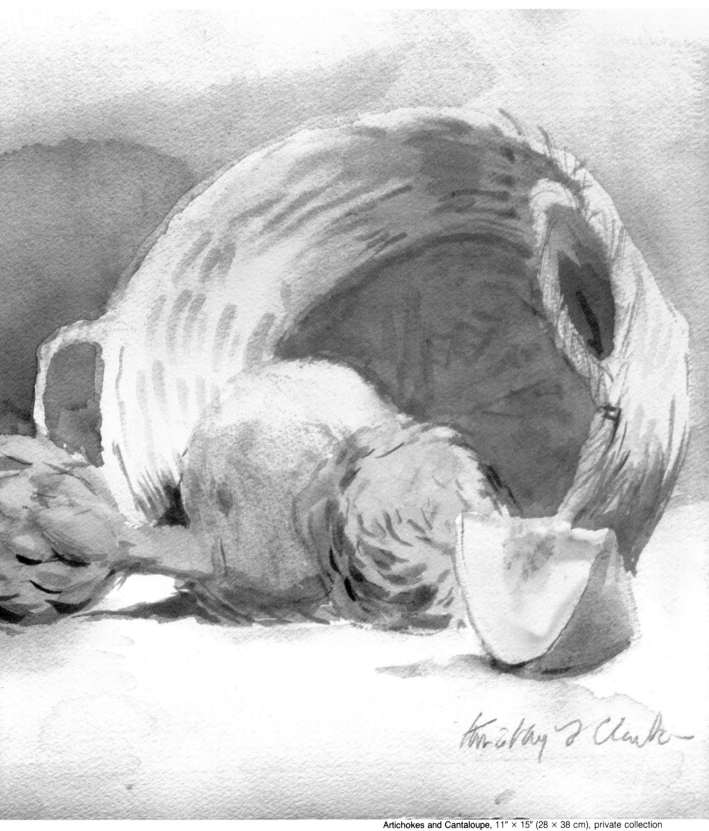

Artichokes and Cantaloupe, 11″ × 15″ (28 × 38 cm), private collection

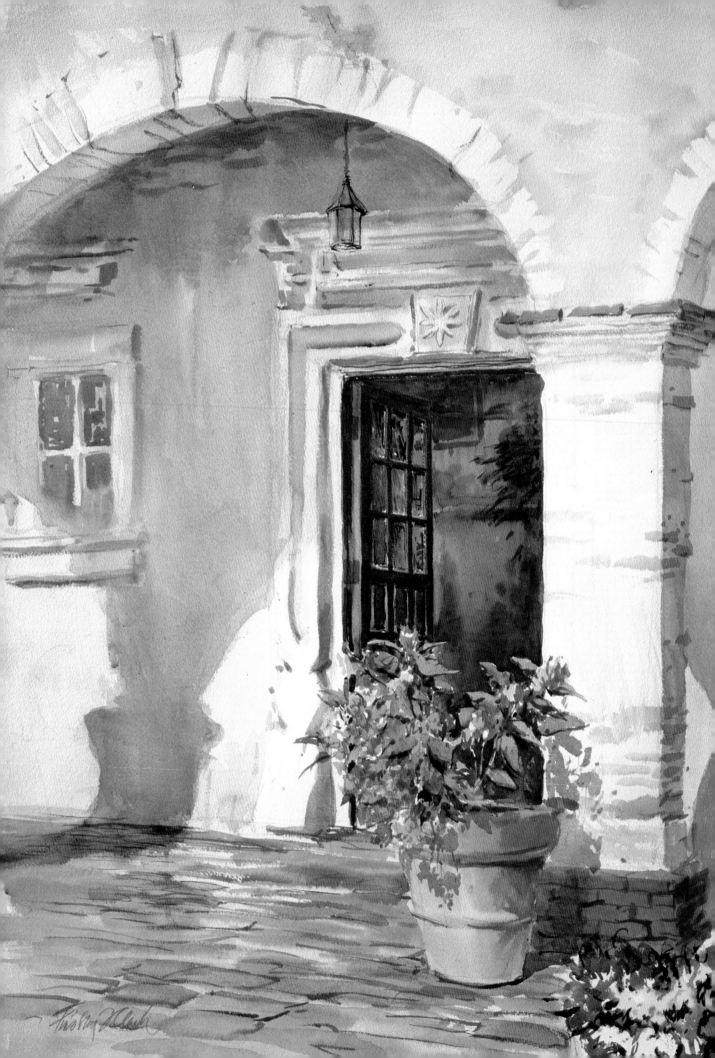

LIGHT AND SHADOW

I don't have to sell you on the importance of light. Not only can it help you describe a form, giving your subject a three-dimensional appearance, but it can also be a powerful expressive element in your painting. I've already mentioned Rembrandt's dramatic use of light. J. M. W. Turner and Edward Hopper are two other artists you might study to get an idea of the expressive possibilities of light.

For the light in your painting to be believable, you must first understand some basic principles about the way we see light on form. The highlight, light, halflight, core and cast shadows, and reflected light follow a predictable pattern, as you will discover in this chapter. Once you master these basic rules, you can build on them to present your own personal vision.

One point to remember with watercolor is that it's usually best to work from light to dark. The lightest areas in your painting will probably be the white of the paper, so they're already there when you start. Some artists then like to build their darks gradually, in layers, because it's much easier to go darker than to go lighter in watercolor. Two light washes combined will give you a darker wash. But don't worry if you make a mistake. If you make an area too dark, you can usually rewet it and blot the paint.

Before you begin this chapter, you might want to quickly review the material on handling values on pages 24 and 26. But conveying a feeling of light isn't just about controlling values. There are also different ways in which you can use color—playing on the interaction of complements or warm and cool colors—to augment the feeling of light (see page 70). Exploring this interplay of color and light can be an exciting challenge, leading into endless painting possibilities.

San Juan Door,
30'' x 22'' (76 x 56 cm),
private collection

Simplifying Light and Shadow

Depicting light and shadow can become quite complicated, but it's a relief to know that the basic ideas are very, very simple. You can actually do a painting with just one color, one value, and the color of the paper. This exercise is not a gimmick; it "forces" you to come to grips with the underlying structure of almost any light and shadow statement, so you wind up acquiring a very valuable skill.

To begin, make sure your subject is well lit, with a single light source: either sunlight or a spotlight. This exercise requires strong directional lighting. Don't use several light sources or paint under fluorescent lighting in a kitchen.

The first step is to decide which areas are in the light and which are in shadow. Actually, since watercolor paper is usually white or off-white, the lights are already painted. All you really have to do is to decide where the shadows are.

While looking at your subject, squint to simplify the light and shadow areas. You must determine whether an area is light or shadow—either/or. In this painting there are no in-betweens, no halftones. What you are creating is a hard-edge painting, very much like a high-contrast photograph. Be decisive: there is no room for haphazard guesswork. You can't rely on magic or a special technique to make this exercise work. Instead, you need to develop your ability to observe what classifies as light and what as shadow.

The results of this exercise can be surprising. This kind of painting carries an amazing amount of information. Some-times it even seems, mysteriously, to contain more information than a painting with several different values in it. And often it suggests more information than the painter has actually put down. On the shadow side of a face, for example, you may well "see" an eye, even if it's not painted. What happens is that your imagination supplies the missing details. Once you realize this, you may be more willing to make a simple statement and to concentrate on the underlying design, rather than copying every detail.

You might see this kind of painting as a counterpart to contour drawing, as it extracts information from a limited field (light or shadow). And, as in contour drawing, the final image can be surprising in its stark honesty. The biggest difference is that the contour line tends to be more decorative.

Once you can reduce a subject in this way to its basic light-dark structure, adding variations of tone within the light and shadow areas becomes manageable. And understanding this structure can help you unify a painting if the values become too complicated. Often I superimpose a simple value structure over an established painting to clarify the light and shadow areas and help me bring the whole together.

One final tip: remember that the reflected lights are in the shadow family (see page 66). Too often students falsely exaggerate the reflected light into a full light and end up with a confusing statement.

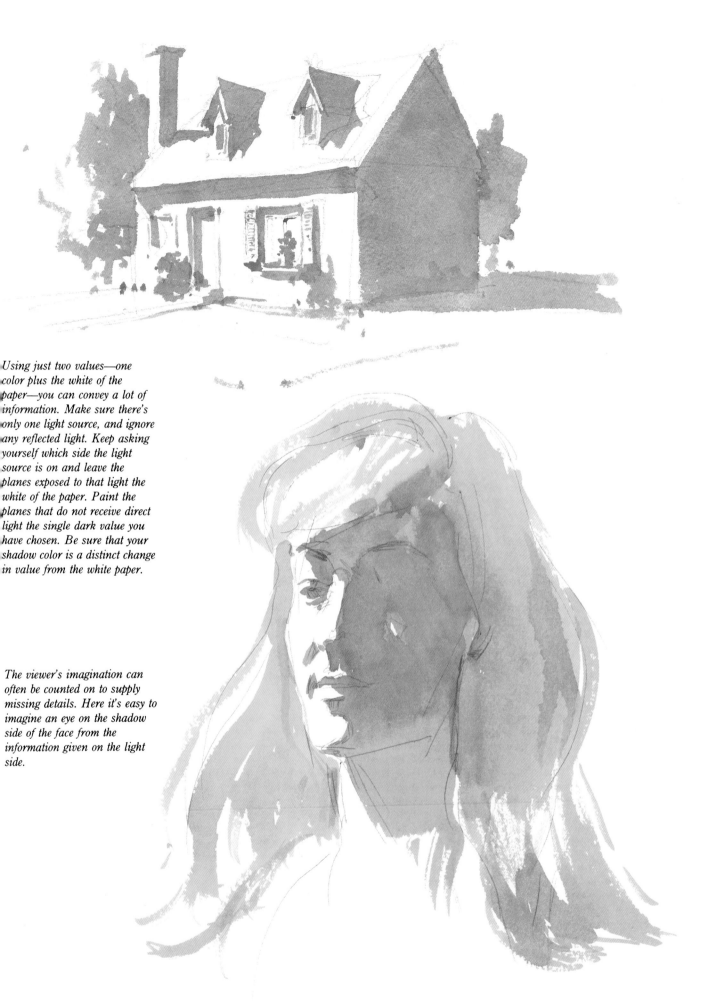

Using just two values—one color plus the white of the paper—you can convey a lot of information. Make sure there's only one light source, and ignore any reflected light. Keep asking yourself which side the light source is on and leave the planes exposed to that light the white of the paper. Paint the planes that do not receive direct light the single dark value you have chosen. Be sure that your shadow color is a distinct change in value from the white paper.

The viewer's imagination can often be counted on to supply missing details. Here it's easy to imagine an eye on the shadow side of the face from the information given on the light side.

Defining Form with Light

There's a simple equation to remember in developing form: color (both the local color and any reflected color) + value = painted form. Essentially this formula builds on the exercise you just completed, incorporating what you have learned about the basic light-dark structure with the use of color. Keep in mind that a clear system of light and shadow has a strong graphic quality in itself. Don't be afraid to use this to clarify the forms in your painting. If you work only with the local and reflected color (see pages 66, 70), your subject will tend to take on a flat look. But when you add the shadows, you should be able to render form convincingly.

Take a look at the example here to see how this equation works. Admittedly, I

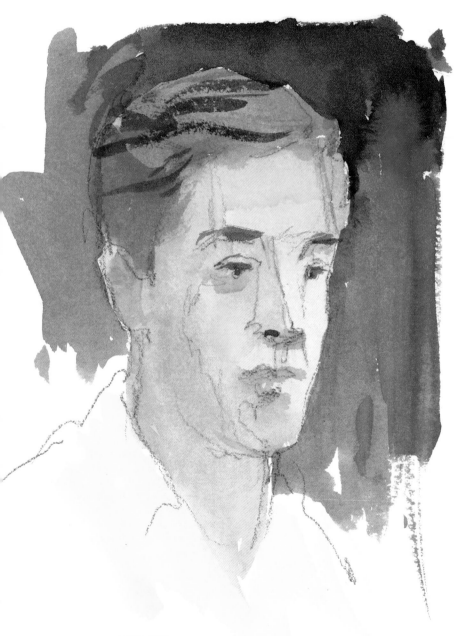

COLOR
(BOTH LOCAL AND REFLECTED COLOR)

+ VALUE
(OR SHADOW SYSTEM)

fudged a little, because it's important to modulate the color from warm to cool within the shadow system. In the finished portrait, for example, there is a warm shadow along the side of the head, but along the jawbone, just in front of the ear, it takes on a cool blue-green cast, suggesting stubble. Also notice the stroke of yellow under the chin (a reflection from the shirt) and how this adds to the thrust of the head when it's contrasted with the cool purple shadow on the neck. There's also a touch of yellow on the nose and a purple shadow underneath. These modulations contribute to the feeling of light, but you could—for simplicity— wash a single shadow over the painting, and it would still unify the piece.

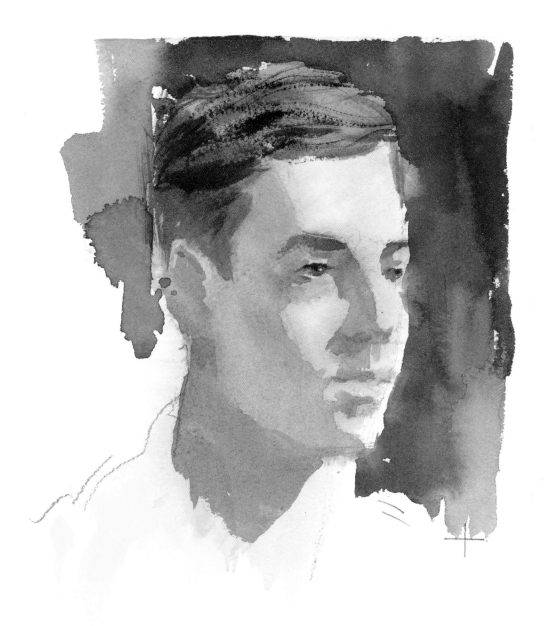

= **FULLY DEVELOPED FORM**

Developing the Core Shadow

The two-value exercise gives you a basic understanding of light and shadow, but most artists go beyond this, adding subtler values within the lights and darks. These variations in value can help you suggest the volume of a form. The diagram on this page shows you some of the main things to look for: the light, highlight, core shadow, reflected light, and cast shadow. Notice how these areas relate to each other and how their shapes relate to the shape of the ball.

On the dark side of the ball, there's an area called the *core shadow*. This area is usually the second darkest within a light and shadow system, with the darkest usually being the cast shadow. Often the core shadow appears as a dark band, sand-wiched between the light and the reflected light.

Except on square or rectangular objects like boxes or buildings, the core shadow has a soft edge. This is an important point to keep in mind because a soft edge can help you explain the roundness of a form. It also conveys the softness of diffused light in the shadow area. With watercolor, you can enhance the soft-edged quality by working wet-into-wet.

The core shadow may be painted in the local color, or a neutral or cool version of this color. It is unlikely, however, to be warm. And, in any case, it should be worked closely with the light and the reflected light, as well as the cast shadow, so there are no jarring disjunctions.

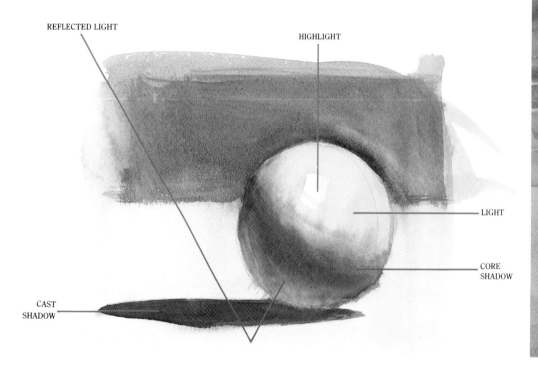

The placement of lights and darks in this picture makes the direction of the light source clear. Notice the variety of edges in the different areas. The core shadow, for example, has a soft edge on this rounded form, while the cast shadow has a hard edge in direct light.

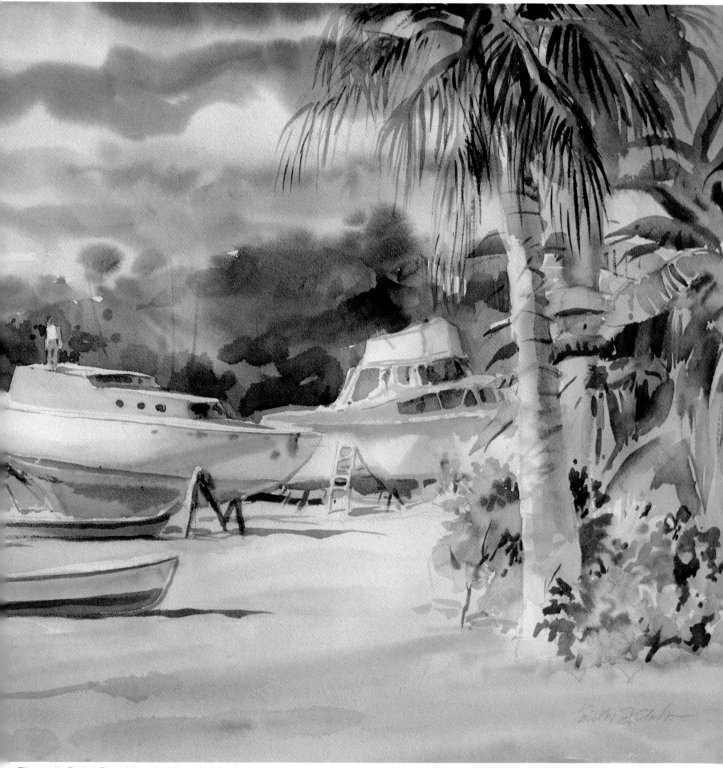

Zihuatanejo Fishing Fleet, 22" × 30" (56 × 76 cm), private collection

Tropical subjects like this appeal to me because the exotic vegetation and bright sky provide a full range of color and value. On this sunny, hot beach in Mexico the light shining off the white sand made the core shadows and reflected lights quite pronounced. The cast shadows were also very pronounced, as the three usually go hand in hand.

You can see the core shadow clearly on the hull of the large white boat with the men standing on it. To paint this core shadow, I first laid in the light on the hull and then immediately washed in the overall shadow, although not the darkest value. While all this was fairly damp, I brushed in the dark stripe of the core shadow, giving it a soft edge. Later, when I put in the dark foliage, the contour of the boat took on a clean-cut, hard edge, setting up a contrast between the graceful hull and the lush foliage.

Now take a look at the cast shadows, which are quite dark and cool. Although the cast shadows were actually boat-shaped, I painted them as thin, wavy lines because that was how they appeared with the uneven sand and my low eye level.

Working with Cast Shadows

As we've seen, under direct light, the cast shadow is usually the darkest area within the light and shadow system. In clear light, as opposed to diffused light, the cast shadow will have a hard edge. Outdoors, its color is generally a bit cooler than the overall color scheme—assuming the light source is warm or neutral. A cool dark like this can be more than a shadow; it can also accent the warmly lit object.

If you're not sure about the length and shape of a cast shadow, you can plot it by drawing an imaginary line from the light source through the leading edge of the shadow on the object onto the surface on which the cast shadow lies. Also keep in mind that, if you're working with bright, clear lighting, the cast shadows will be dark and hard-edged, so it's best to paint them toward the end. That way you can make sure the paper stays dry and the paint doesn't run. Then, if the edges need a bit of softening, you can use a wet brush.

Often the cast shadows in a scene provide exciting design opportunities. The shapes of the main objects are generally repeated in flat variations in the shadows, setting up interesting echoes across the painting surface.

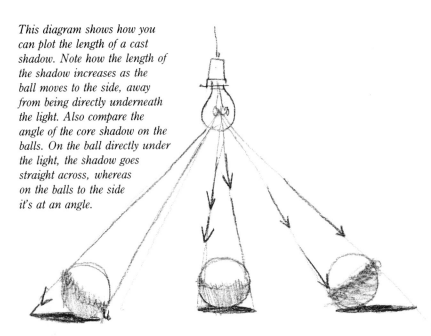

This diagram shows how you can plot the length of a cast shadow. Note how the length of the shadow increases as the ball moves to the side, away from being directly underneath the light. Also compare the angle of the core shadow on the balls. On the ball directly under the light, the shadow goes straight across, whereas on the balls to the side it's at an angle.

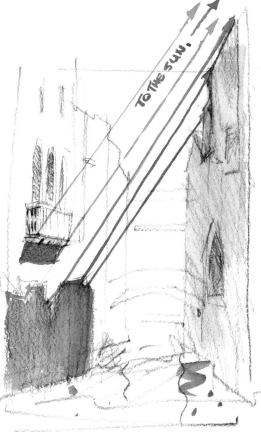

If you're working outdoors, you should be able to draw an imaginary line from the corner of the cast shadow to the corner of the form toward the sun—or vice versa. Keep in mind that as the sun gets lower in the sky, the cast shadows will rise on the buildings.

Painting the areas of light and shadow in Venice is an exciting challenge. With all the reflections in the water, there's a wonderful play of opposites: warm against cool, light against dark, solid against fluid. Here the right side is in shadow and the left in light. Notice that the cast shadow on the left is a middle value, breaking the rule that cast shadows are the darkest. This is because the afternoon light was slightly diffuse.

Actually I started painting this on the last day of a watercolor workshop in Venice. I had completed the drawing and laid in some of the lightest washes when the sun disappeared, leaving the left side as well as the right in shadow. Fortunately, I had other paintings and some photos, which helped me complete the painting in my studio. I find that looking at the color and light in related paintings jogs my memory and aids my color choices. The photos help a bit with details and values, but the color in them usually does not jibe with what I select to see.

Near Belsito
30" × 22" (76 × 56 cm),
collection of Mr. and
Mrs. Charles Elliott

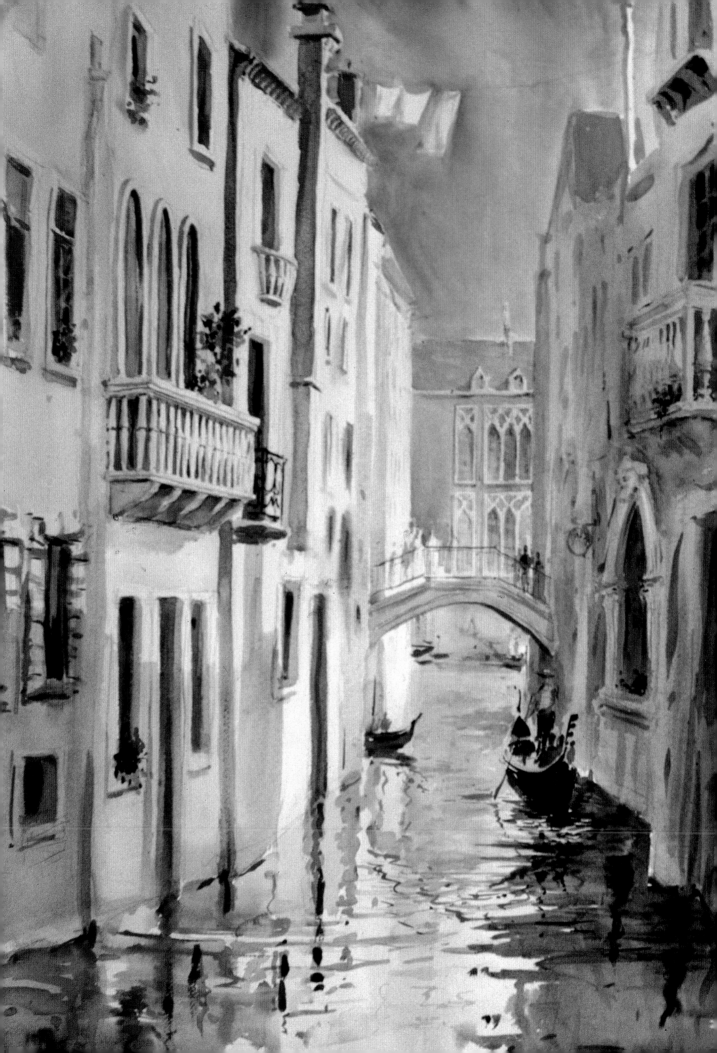

Accounting for Reflected Light

Between the core shadow and the cast shadow is an area known as the reflected light. What happens is that light that hits another area bounces back, in a diffused state, and softly illuminates the bottom or far edge of a shadow. It is important, however, to remember that the reflected light is in the shadow family, with a darker value than anything on the light side of the form.

The color of the reflected light can vary dramatically because it is a combination of the color of the light source and the surface that reflects it. Because of the warmth of sunlight and incandescent light, the reflected light is usually warm. But this may change if the reflective surface or the light source is cool. A blue or green shirt, for example, might reflect a dramatic cool on a subject's chin.

You can paint in the reflected light when laying in the basic shadow area. The point to keep in mind is that the color of the reflected light tends to be more intense than that of the basic shadow. The change is not so much in value as in intensity. Also, remember that the edges of reflected light are soft. Essentially, what you do is to make the basic shadow color a bit richer in the area that ultimately will become the reflected light. When the core and the cast shadows are added later, the reflected light will glow.

The sun was very hot the morning I painted these chapel doors in Brittany, France. I enjoyed the way the light bounced off the steps and the doors and collected in a warm glow under the carved stone entry.

Because the closed doors stop the viewer's eye at the top of the stairs, I paid special attention to the glow on the stone and the pattern of the wood panels, bolts, and hinges to make sure they would sustain the viewer's interest. The carved stone was actually easy to paint. The "trick" was to simplify it into a basic light and shadow pattern, using only three values: a light, a dark, and a slightly darker cast shadow. Then at the end I added the intricate rail, painting its dark value right over the stairs and doorway.

Doors to Our Lady of the Brambles, 22″ × 15″ (56 × 38 cm), private collection

It is not uncommon to find even green reflecting on the face. Remember that with almost any surface the light hits, it will bounce back and reflect onto whatever is nearby. In this case the dress reflects up onto the chin, cheek, and bottom of the nose.

66

Painting the Lights

Now let's look at the lights. Consider the angle of the light on the form. An area directly under the light will be lighter than an area obliquely hit by the light. It may help to imagine the object as a series of faceted planes and to see how the value gradually changes from light to dark as the light travels around the form.

Rounded forms usually have a highlight, which may be as light as the paper white. The location of the highlight depends to a certain extent on the viewer's position. Look, for example, at a shiny ceramic or glass object and move your head slightly. The light and shadow areas will remain constant, but the reflection will move in the same direction you do.

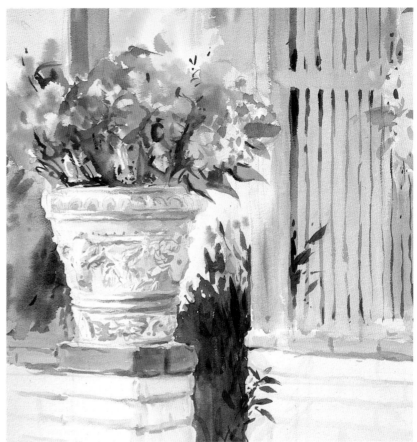

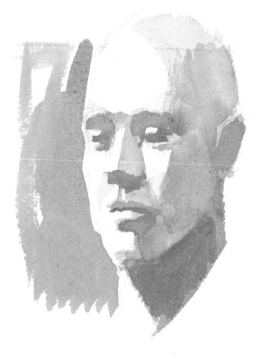

The white areas in this sketch clearly show the direction of the light. At the same time they define some of the main planes of the head.

In watercolor the lightest areas are usually the white of the paper, as can be seen in these details. Also notice how the darks and background colors help to define the lights and add to their impact. Without the shadows, the lights would be meaningless.

Arboretum Passage, 40″ × 25½″ (102 × 66 cm), courtesy of the Esther Wells Collection

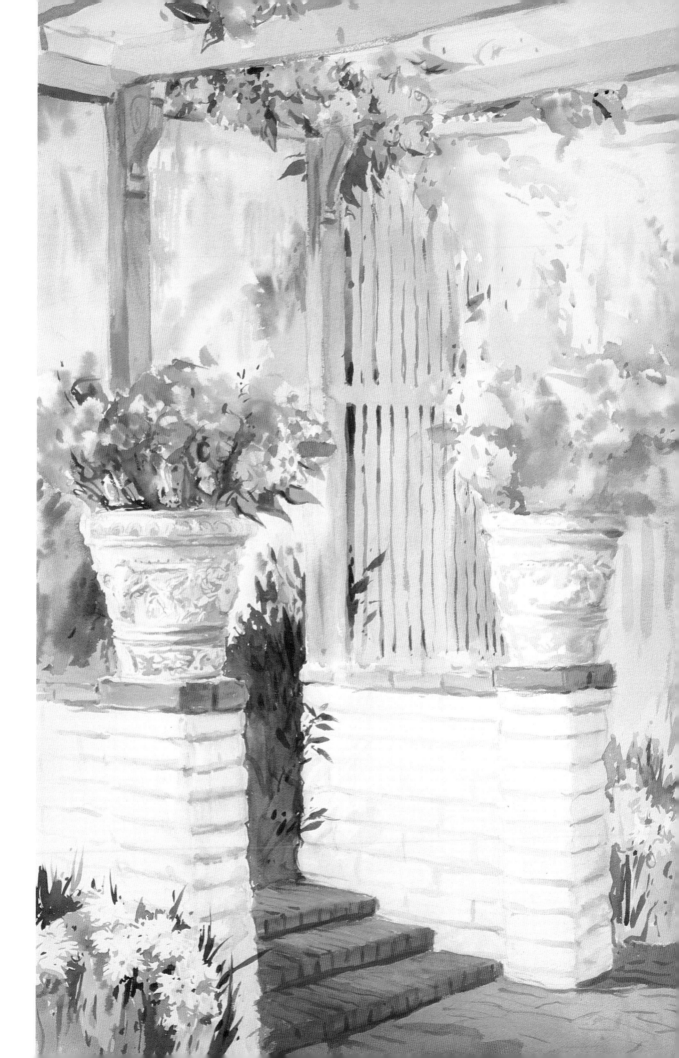

Understanding Color and Light

Earlier, on page 60, I showed you a simple way of combining color and light to define form. But the interaction of light and color is much more complex, and there are many different schools of thought on the subject. Some painters use primarily lighter or darker values of the same color, while others play more with the interaction of complements—adding purple, for example, to the shadows on a yellow object.

Essentially, there are three factors to consider. First is the *local color*, the "true" color of the object—for example, a red rose or a blue shirt. Then there is the *color of light*. Often on cloudy days, the light is cool or blue. At sunset or sunrise, the light may be red or yellow, even purple. Incandescent light bulbs give a yellow glow, while fluorescent lighting is usually cool. The warmth or coolness of the light then "colors" the subject.

Finally, as we've already seen, there is *reflected color*. A form may pick up the color of a neighboring object—as in the example on page 66, where the woman's green dress is reflected under the chin and the nose.

Showing how the light source and the reflected light affect the local color is a continual challenge. What I like to do is to push the range of color. I don't simply paint a tree in one color of green, adding water to make a pale green in the light area and using less water for a darker green in the shadows. Instead, I may add a warm yellow to my green in the lights, mix in a blue for the moderate shadows reflecting the sky, and then add a red to neutralize and darken the shadows. It is possible to paint a green tree successfully without ever using the "right" green—if the combination of colors suggests the lighting conditions. I like this way of working because it ties in more directly with the way I see and allows me a greater creative range.

The colors in this painting are meant to give the viewer a sense of light. The hot yellow and pink light on the stairs in front turns cooler as the steps move away, into the distance. The cast shadows stretching across the front section are cool, with soft edges for the shadows cast by the leaves high in the tree and harder edges for the shadows cast by the lower branches. The dark purple shadow on the left side provides a strong contrast and helps to direct the eye upward.

The trunks of the eucalyptus trees follow a similar warm and cool pattern to the stairs. The first tree is colored by a pink light with dark, cool shadows. It casts a shadow almost entirely over the second tree. Notice, however, the bright red reflection from the steps and how this adds interest to this area. The leaves then offer another flowing pattern, moving from light yellow-green in the foreground to a soft blue to a near-black green in the shadows.

Admittedly, I exaggerated the color in this painting. At the same time I really did see each of these colors—only I pushed them further, making them pinker or yellower, to create a more exciting painting.

Laguna Stairs,
25½" × 20" (66 × 51 cm),
collection of Mr. and
Mrs. John Andreos

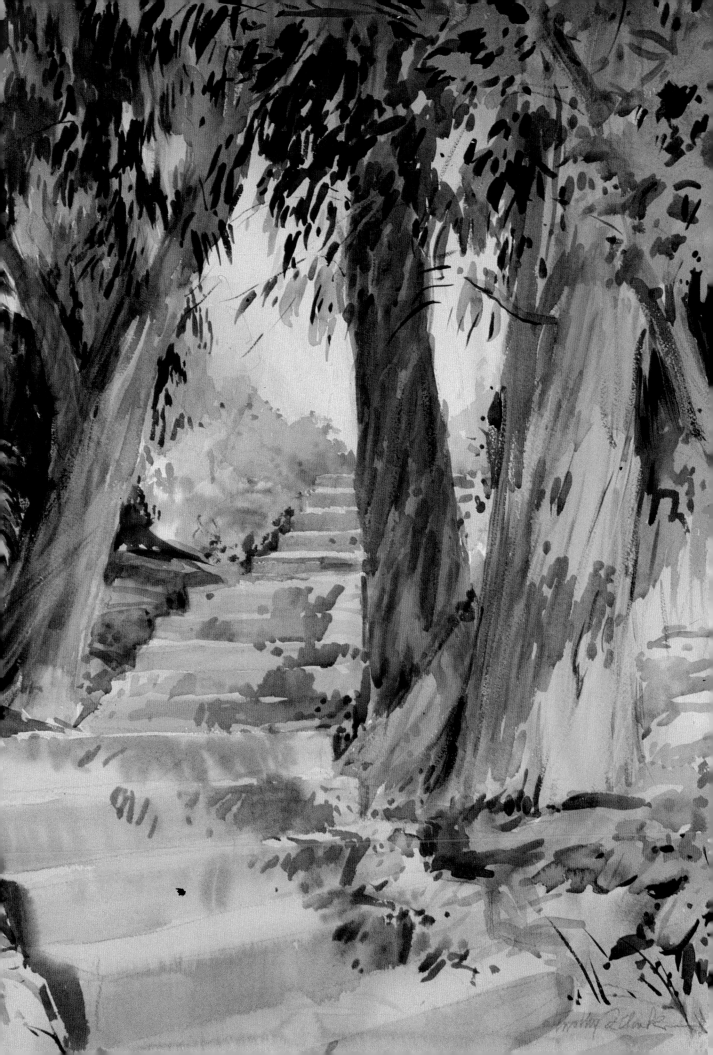

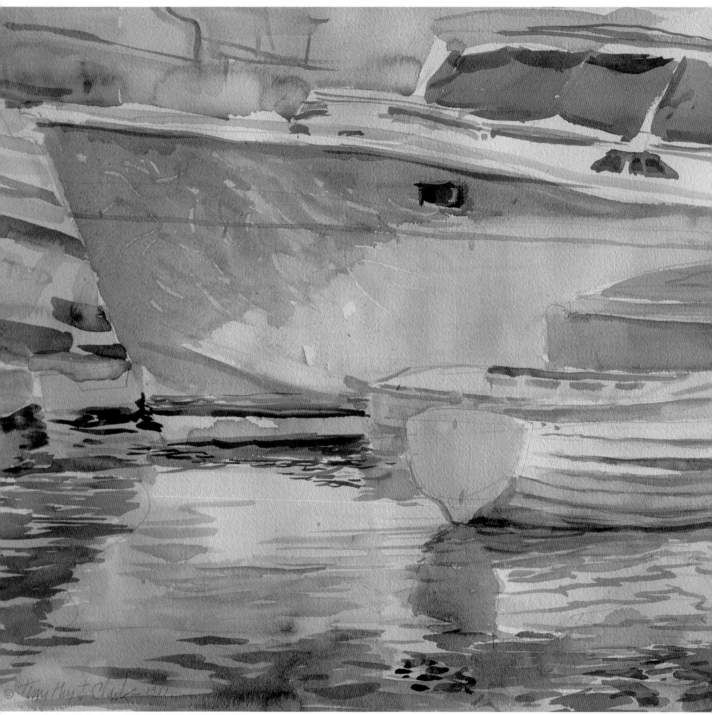

Balboa Reflections, 15'' x 22'' (38 x 56 cm), collection of Regina Clark

WATERCOLOR TECHNIQUES

Learning different techniques will improve your skill as a painter, but it is important not to let technique take over and dominate the painting. The idea is to use technique to express what you want to say, to communicate your thoughts and feelings about a subject.

Consider these two approaches to painting. An artist might say, "I see and feel this about the subject, and I will express it through this technique." The picture painter, on the other hand, might say, "I have a new bottle of Maskoid, and I wonder how I can use it." Both may wind up using Maskoid, but who do you think will create the more meaningful watercolor?

This is not to say that you shouldn't experiment with technique. On the contrary, the exercises in this chapter are designed to open you up to different ways of working with watercolor. But there's a

difference between using technique effectively and being technique-driven. Good technique should be almost invisible because it seems so "right" for the subject.

To reiterate: the best way to avoid gimmicks is to make your visual ideas primary. Use salt, Maskoid, wax, scratching, calligraphy, sanding, collage, or your own invented technique for its expressive and graphic qualities—not because it is an easy way to make a picture.

One final note on technique: it's the artist's responsibility to make sure that the technique he or she uses is as permanent as the situation requires. A magazine illustration done in watercolor can fall apart after it is photographed. But it is questionable ethically to use a technique that may change the painting's color or stability in several months or even years if you intend to sell it to a private or public collection.

Brushwork

The brush may be the greatest invention in painting. A well-made brush is such a beautiful tool that it is hard to remember that it is only animal hair tied to a stick.

Over the centuries there have been some changes in the way brushes are manufactured. Before the metal ferrules used today, the hair was mounted in hollow quills. The size of the brush was determined by the size of the bird that gave its quill. Instead of purchasing a no. 6 brush, an artist might request a swan or a goose quill. A few brushmakers still produce quill ferrules, although metal ferrules are now the standard.

It may come as a surprise to learn that you can't rely on the numbers for size, as brush sizes can vary from manufacturer to manufacturer. A no. 7 from one brushmaker can be larger than a no. 9 from another.

The finest watercolor brushes are made of red sable, from the tail hair of the kolinsky sable (also called the Siberian mink). This hair, with its natural curve and fine point, is unsurpassed by any other material to date. Master brushmakers cup the hairs in their hands and then tie them so the hairs all bulge at the belly of the brush and the ends all meet in one needle-sharp point. Because of the scarcity of the hairs and the skill required to make the brush properly, these brushes are fairly expensive.

If you are just starting out, or if you want a brush for simple washes, you might select a less expensive sable brush, a blend of sable and oxhair, or a durable combination of synthetic and sable hairs. For very large areas, where you don't need detail, a synthetic or inexpensive natural brush is fine.

Now let's take a look at what the brush can do. A fine brush, fully loaded with paint, will act as a mop—a mode that works well for both wet-into-wet and flat washes. For a different technique, hold the brush handle with one hand and sharply tap the ferrule on a finger on your other hand. A good brush will snap into a needle-sharp point. You can then use this point for all kinds of detail and for painting linear statements.

A third possibility is to combine the two techniques just described. Snap the brush to a point and then paint a wash, starting the stroke on the side of the brush, then slowly twisting and lifting it to the point (see the illustration on page 76). In this way you can paint an area that starts quite large and then tapers to a tiny point. This skill comes in handy, especially when you want to paint things like the spindly needles of a palm tree.

Now take a wet, loaded brush; snap it to a point; and then pinch the hairs between your fingers. The brush should flatten so it has a serrated edge. If you lay down a stroke with your brush in this condition, you can simultaneously paint a series of fine lines, creating a linear pattern in a hurry.

For yet another effect, take a loaded brush, put the side of the brush on the paper, and rapidly make a stroke. The paint will adhere to the high "hills" of the paper, but not fall into the crevices, leaving a textural mark and letting the light of the paper sparkle through. This is the easiest way to get a drybrush effect with light colors.

Another way to create a drybrush effect is to mix a fairly stiff batch of paint (with little water) and use a partially dry brush. This technique is usually used with darker colors. Not only does it bring out the texture of the paper, but it can also provide a valuable contrast for fluid washes. And it is a good way to describe rough surfaces, such as wood or brick.

A fully loaded brush acts as a mop. This works well for washes.

The Gateway,
30″ × 22″ (76 × 56 cm),
collection of Mr. and
Mrs. William Madison

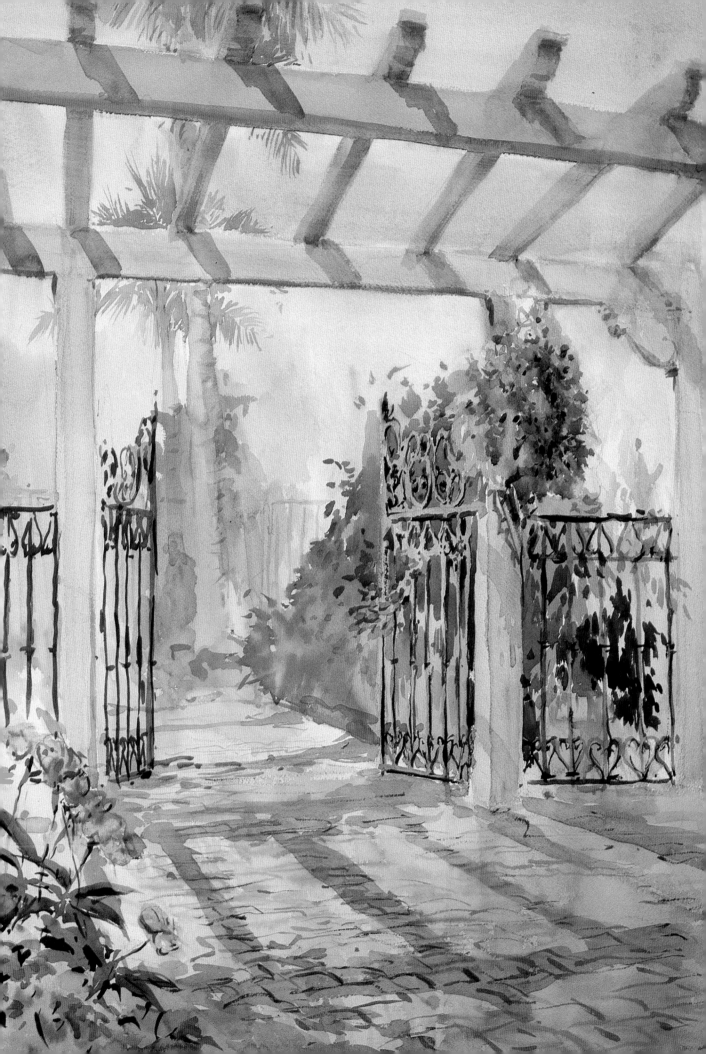

Brushwork

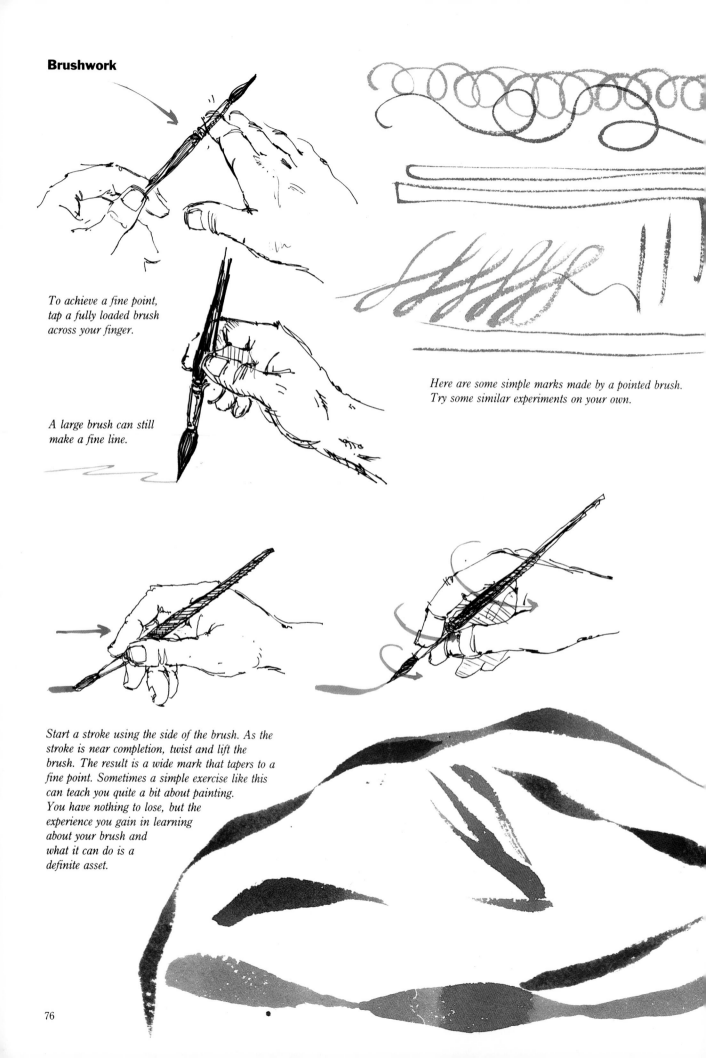

To achieve a fine point, tap a fully loaded brush across your finger.

A large brush can still make a fine line.

Here are some simple marks made by a pointed brush. Try some similar experiments on your own.

Start a stroke using the side of the brush. As the stroke is near completion, twist and lift the brush. The result is a wide mark that tapers to a fine point. Sometimes a simple exercise like this can teach you quite a bit about painting. You have nothing to lose, but the experience you gain in learning about your brush and what it can do is a definite asset.

To achieve fine, comblike marks, take a loaded brush, squeeze the hairs between your thumb and first finger, and then proceed to paint. This form of drybrush works well for rendering wood, rocks, hair, and similar textures.

Now lay your brush on its side and drag it sideways. Only a limited amount of paint is released from the brush, so some of the paper shines through, giving a glittering effect.

Buying and Caring for Brushes

If you're buying an expensive kolinsky sable, it is certainly acceptable to test it first. The five tests I use are similar to the techniques just described. (1) To test the mopping capacity, dip the brush into water and make sure the hairs are full enough to hold a brushload. (2) To check the point, snap the brush across a finger and see if it comes to a point, without stray hairs. (3) Next wet and snap the brush again to see if it is symmetrical. If it pushes to one side, repeat the test. If it fails again, try another brush. (4) Then pinch the hairs and make sure you get a serrated edge. (5) Finally, to make sure the brush has plenty of spring, rewet it, gently push the hairs to one side with a finger, and let the hairs snap back. They should snap back to a near-straight position. If they just flop to one side, the brush is a bit dead and should be rejected.

A good brush will last for years. If, however, you paint almost every day the sharp point will wear down. Still, old brushes are great for washes, even if you can't use them for details.

A quick word on caring for your brushes: an occasional washing with a mild hand soap is fine. It is hard to say how often because if you have just three brushes, they will get dirtier faster than if you use a dozen. When your washes begin to look a bit dingy, try cleaning your brushes. Here is what I do: I lather, rinse, lather, and then rinse real well so that no traces of soap are left to react with my paint.

Good brushes require care even when they're not in use. Don't, for example, put a fine brush in a drawer unless it is packed in mothballs or something to protect it against insects, as they may lay eggs in the hairs and ruin the brush. If you leave the brush out, every ten days or so stroke the hairs for a few seconds so the bugs won't get a chance to eat them.

Brushwork

In the painting of my daughter Regina Marie, I used the side of the brush to let the sparkle of the white paper shine through the green foam and the blue sea further back. Remember, however, that drybrush is only a technique. Use it judiciously to convey a particular texture or whatever, but don't let it take over the painting.

There's a lot more than drybrush technique going on here. Look, for example, at the girl and the clear pattern of light and shadow on her hat, dress, arm, and legs. Notice how the hat casts a shadow over most of her face but also allows some wonderful warm light to filter through. Now compare the cast shadow, running off to the right, with the reflections dropping straight down from the girl's feet. The cast shadow has a definite edge, while the reflections move in and out of focus on the wet sand.

All the elements discussed so far, including the flickering water and reflections, express light. The wave then suggests the movement of the sea. And there's a third aspect of nature: wind, symbolized by the dress with its skirt blowing in the breeze and the sailboats in the distance.

At the same time the wind symbolizes the free spirit of the girl. And it is the girl who attracts our attention. One wonders what kind of daydreams she has, with the sun shining on her and the water lapping and then receding away from her feet.

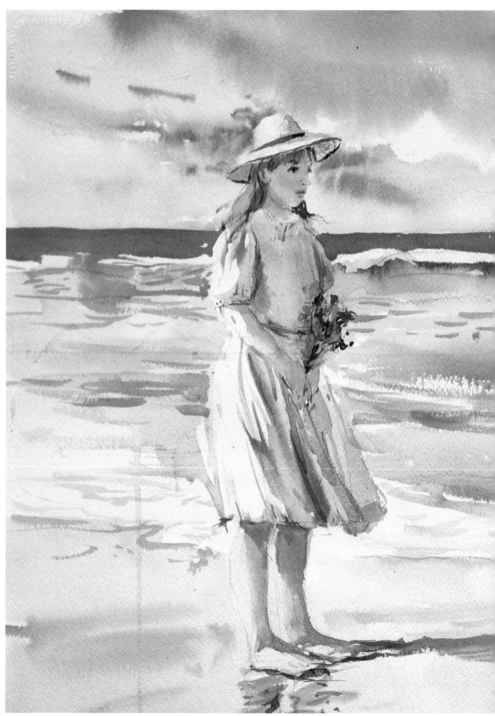

Regina Marie, 15″ × 20″ (38 × 51 cm), collection of the artist

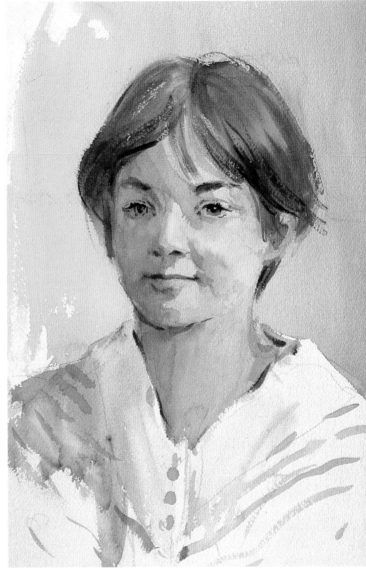

The Artist's Daughter, Ginevra, 15" × 11" (38 × 28 cm), collection of the artist

In my painting of Ginevra, you can see how using a brush with split hairs helps to suggest the texture of hair. To paint this portrait, I first laid in a wash over the entire head and neck. Then I dropped in warm pinks under the nose, on the cheeks, and around the eyes. Next I worked on the shadows on the left side of the face, using quite a bit of blue to balance the warm flesh and hair.

To develop the hair, I concentrated on the light and shadow pattern. Once that was established, I added the dark accents, using a brush with split hairs. Notice how these strokes suggest the individual strands of hair, introduce a feeling of texture, and help to model the head.

Ginevra posed for about an hour for this portrait, and she did a great job. One thing that helps is that I don't require absolutely motionless poses. As long as the sitter can come back to the initial position, I find that some movement lends a sense of animation to the piece. Also, I try to keep up a running patter with my model—both to put the sitter at ease and to avoid boredom.

Pouring Paint

Pouring paint from a cup directly onto your paper is a daring and exciting way to paint. It is almost guaranteed to promote freedom and stimulate an intuitive approach.

To experiment with this technique, take two pieces of paper, one wet and one dry. Mix a small amount of pigment and water in a paper cup and pour away. The wet and the dry paper will take the paint differently. On the wet paper you should be able to get velvety passages, with soft, blurry edges. Although the paint runs and bleeds, it is actually easy to control if you tilt the paper and let the paint flow follow gravity. With dry paper, on the other hand, you'll get a more linear statement. The drips remain as clear-cut fingers; they do not blend into the paper. This method can be much harder to control, for the drips seem to zigzag and go wherever they please.

When I experiment with pouring paint, the results are usually abstract. But, just for fun, you might try to work in a figurative style without using a brush, as I did in the landscape on page 82. Start by pouring paint on wet paper to create soft areas, controlling the paint by tilting and tapping the paper. You can even speed things up by using an electric hair dryer. As the paper dries, continue pouring paint but now control the direction by blowing through a straw. Or use your imagination and invent another technique to control the flow. Take care, however, not to lose the freedom this exercise is meant to encourage.

Another thing I like about pouring paint is that the paint quality has a wonderful freshness and simplicity. Too often artists overwork their paint with the brush. By watching what the paint wants to do when it's poured, I feel I'm better able to stay fresh when I do pick up my brush.

On occasion I will start a painting by pouring directly onto the paper. This method works especially well with skies and backgrounds. But, most important, the freshness of pouring may inspire my brushstrokes. Pouring or loosely painting large areas as an initial step has a history. It's said that J. M. W. Turner would prepare several loose paintings at a time and then later take them out on location and draw and paint into them.

These paintings were literally poured from paper cups. The first was done on dry paper so the shapes have fairly hard edges. The other two, which were poured on wet paper, show more variety, with the edges ranging from hard to very soft and the colors from very light to near-black. Parts of the painting almost seem to explode off the page.

Even though these paintings are experiments and do not represent the direction I have chosen as an artist, they teach an important lesson: that the paint itself can have some interesting things to say. Don't make your brush do all the talking; give the paint a chance. You might be surprised at the results.

Pouring Paint

Some of my students had doubts about the practical application of pouring paint, so I did this painting as a demonstration of how you can depict a recognizable subject without ever using a brush. Starting with very wet paper, I poured on some pink and blue, which became the sky. Next I poured green, orange, and brown into the foreground and then let gravity carry this across the page as I held the painting on its side. After pouring on some blues, greens, and purples for the trees, I took a straw and blew at the purples, so the paint ran in crooked lines, suggesting gnarled branches. When I got the effect I wanted, I used a hair dryer to stop the paint from running.

To me, this painting carries the feeling of a misty morning sunrise—an effect I achieved without ever using a brush. The point, once again, is to learn to let the paint have some say.

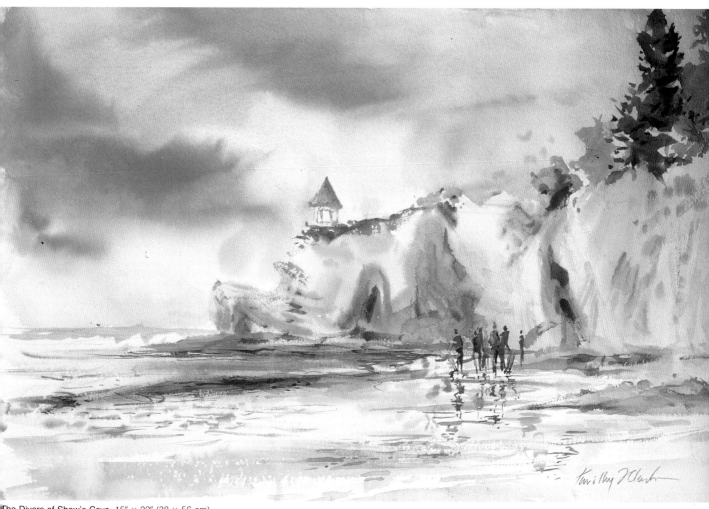

The Divers of Shaw's Cove, 15″ × 22″ (38 × 56 cm)

Sometimes I use the technique of pouring paint to finish a painting. Here I felt that the sky shape was too bland, so I wet the sky area with a brush and mixed a solution of ultramarine blue with a touch of alizarin crimson in one cup and Winsor violet with a touch of cadmium red in another cup. I then poured the Winsor violet mix near the top of the paper, toward the right, and the ultramarine solution toward the left side, a bit lower. To direct the flow of the paint, I tilted the board. Finally I introduced some warm cadmium red accents with a brush.

Instead of a flat, uninteresting area, the sky has now become quite dramatic. Notice how the space between the blue and purple areas suggests a light cloud.

Scraping

You may already be familiar with the technique of scraping—dragging a sharp object across the wet paint to create a light area. The most common tool for this is the angled edge of a flat watercolor brush. Yet, because the mark the brush handle makes may be readily identifiable, many artists avoid it and instead use the corner of a credit card, a pocket knife, or even their fingernails. J. M. W. Turner, for example, grew one of his thumbnails quite long and kept it razor-sharp for this purpose. That was certainly a customized personal tool!

In addition to choosing the appropriate scraping instrument for the effect you want, make sure the paint is in the right condition: not too wet or too dry. If the paint's too dry, scraping will have little or no effect. If it's too wet, scraping will clear a light passage for a moment, but then the paint will flow back, darkening everything again. Keep in mind that on a hot day with little humidity you may be able to scrape immediately after painting a wash, but on a cool day with high humidity you may have to wait several minutes.

Another word of caution: don't scrape too hard. If you do, you'll leave frayed fibers that will act as a wick and attract paint, so you may end up with a dark passage instead of a light one. It just takes some experimenting to get the hang of it.

One final tip: raw sienna is an excellent color to scrape. It seems to be "forgiving" and is ready to scrape soon after you put it down. Also, it tends to stay put (not bleed back into an area). If you know ahead of time that you want to scrape an area, try adding a bit of raw sienna to your color. If you add just a touch, the pigment may have less effect on the color than on its handling quality.

This example is scraped with too little pressure. The center is light, but not as light as it could be.

Here too much pressure has been used. Although this does the job, making the inside area quite light, there's a problem: the excess pressure frayed the paper, letting little drops of wet paint collect and dry into dark lines. At times you may want this effect, but it can be annoying.

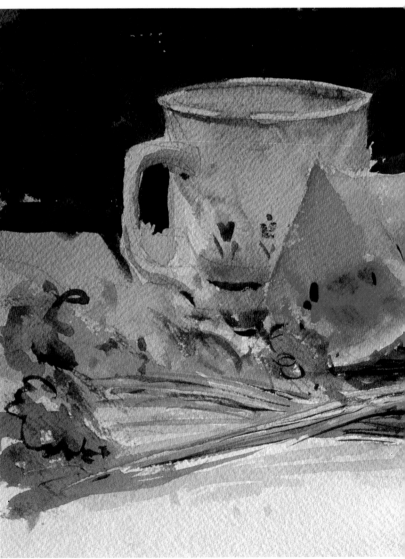

Produce, 8″ × 15″ (20 × 38 cm), collection of Regina Clark

This is the best example of scraping on this page, timed about right with the proper pressure. Notice how the paint was pushed out by the back of the brush with the scraping strokes.

Here the stroke was made too early, before the paint was dry enough. It started out great, but then the paint bled back into the scraped area.

In this last example, the stroke was made too late, when the paint was too dry. Almost nothing happened. In an attempt to force it, I went over it with harder strokes, which resulted in dark lines, instead of light ones.

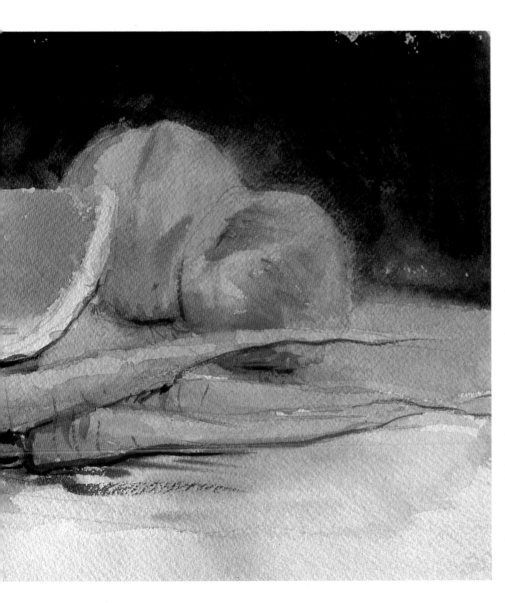

In this small painting the green tops of the carrots have a series of long, dark and light lines. Instead of painting each value separately, I painted the middle value and then, while the paint was still wet, lightly scraped out the lightest greens with a credit card, using long, fluid strokes. Later I went back in to add the darks, without touching the light area.

I consider this a successful use of scraping because the technique works naturally, becoming almost unnoticeable. In other words, it functions in the true spirit of watercolor: it flows without being contrived. Had I painted around all the light areas, instead of scraping them, it might have looked tight.

Another reason I consider this piece successful is that my wife, who is my best critic, grabbed this painting for her collection. I was honored.

Masking Solutions

In watercolor both very light and white areas present a challenge, and you must plan for these areas from the start, "saving" them from the darker colors you put down. One way to do this is to use a masking solution, such as Maskoid—a rubber-based liquid that you brush onto the paper in places you want to leave white and that are difficult to paint around. Once these areas are covered with the masking solution, you can paint over them without worrying. Later, after the paint has dried, you can remove the masking solution by rubbing it with an eraser (a rubber-cement pickup), exposing the white paper again. This can then be tinted or left white.

A variation of this procedure is to paint a light color on the paper first and then protect this color with Maskoid. After the darker colors have been painted, the masking is removed, with the original color underneath undamaged.

Especially when you are just beginning to work with watercolor, Maskoid seems like such a great invention that it is easy to overuse it. There are some problems, however; so use it sparingly. A major difficulty is that the masking solution tends to make all the edges hard. Often it is necessary to take a bristle brush or piece of cloth and scrub part of the edge so the shape does not look too mechanical. Occasionally, especially if it is left on for extended periods, the masking solution may dry permanently into the paper, leaving its color as an underlying tone or yellowing the page. It can also get sticky and attract dirt, which may be impossible to remove. Finally, when you erase the Maskoid, you may lighten the color in the area and leave smudges.

All this is not to scare you away from Maskoid. It does allow you to preserve whites in some intricate areas, and it certainly expands watercolor technique. Just remember to use it judiciously. Don't let it become a gimmick.

Basque Village, 22″ × 30″ (56 × 76 cm), private collection

This painting provides a good example of the appropriate use of masking solution. Take a look at the fine, thin edge of light on the wrought-iron gate on the left. It would have been nearly impossible to have painted the middle-value wall behind the gate while preserving this light. By painting on the masking solution first, over the linear parts of gate, I saved a lot of time and headache.

After I erased the masking solution, however, it was not magic. All I had was the white silhouette of the gate, which was hardly enough information for the viewer. I went on to paint the darks, trimming down the light area considerably, until I got the effect I wanted.

And that wasn't the end of it. I still had to paint the cast shadows. Even though the cast shadows were what caught my eye to being with, I waited until the end to put them in. In many ways the rest of the painting was a showcase for the shadows. Adding them then pulled the painting together. I especially like the way the lacelike shadows of the fancy gate contrast with the massive shadows of the building, stretching across the street.

As you can see from the finished painting, this little village was peaceful. During the two days I painted, only one car and two donkey carts came down the street. The entire community (ten people) came out to scrutinize me on the first day. But by the second day I think I was an honorary citizen. They recognized that I saw beauty in their village.

Resists

In watercolor the term *resist* refers to a waxy mark on the paper that repels the paint and preserves the white of the paper. You can paint right over this mark without any color adhering.

One of the advantages of this technique is that, by using a piece of wax sharpened with a razor blade, you can put down a very, very thin line with the same gesture as a brushstroke. You can't, however, erase the wax in the same way you erase masking solution. In part for this reason I usually put a light-colored wash over an area first and then put the wax on top, so it repels any subsequent color. I find this light color more attractive and useful than a stark white that cannot be changed.

In terms of materials, I prefer to use a simple candle instead of a wax crayon, because the pigment in the crayon may change and affect the final statement. An uncolored candle will give you a clear mark on the paper, revealing the white of the paper or a previous wash without changing its color.

To give you an idea of just how dramatic this technique can be, I'd like to relate an experience I had looking through the collection of the Metropolitan Museum of Art in New York. I came across a watercolor by John Singer Sargent that amazed me with its very fine light lines. As I looked at it, I became convinced that Sargent had painted around each line. I decided then to be more careful in painting around light areas. Years later I went back to look at that watercolor because I had become haunted by Sargent's uncanny ability to paint around such subtle lights. As I tilted the painting on its side, I saw a flash of wax—I had been mistaken.

Obviously, one "moral" to be learned from this story is that it may take several looks before you realize that this technique has been used. But, for me, there was an extra bonus in being fooled, for I disciplined myself to paint around the lights instead of using Maskoid or a resist. With a little patience, I can get results that are technically close to those with a resist or Maskoid, but because everything is done with paint, it appears more natural. Still, there are times when using a resist or Maskoid comes in handy.

Father Serra's Door, 30″ × 22″ (76 × 56 cm), courtesy of the Esther Wells Collection

In this painting I used a resist in the decorative door frame and along the bougainvillea, to preserve a few light branches. I knew from the start that I wanted the washes on the old mission building to be light and soft; using a resist allowed me to paint around the complicated decoration without becoming stiff and mechanical. The advantage of wax in this case was that it gave a softer edge than Maskoid would have done, in keeping with the loose, painterly feeling of the rest of the paintings.

Initially I was intrigued by the arching bougainvillea and its shadow echoing beneath. Notice, for example, how on the upper right side of the door the shadow follows the cut stone in a zigzag pattern. Not only is this line decorative in its own right, but it also helps to explain the form. Also notice the reflected light glowing on the ceiling just inside the entryway—something I particularly enjoyed painting. It offers an important contrast to the cool cast shadow hugging the inside wall and door jamb.

This subject, with its many intricate white areas, demanded both freedom and control in the handling of the paint. It was tempting to use Maskoid or a resist for the waterfall and the white leaves, but I was able to avoid these techniques and remain in control. Here is what I did.

First, I painted the subtle shadows on the white leaves. If you try something similar, you'll find that subtle whites on white paper don't have much impact. Don't worry—just pace yourself. In this case, the next step was to begin painting the greens around the white leaves. In this way I not only defined the foliage, but also brought that needed impact to the white leaves.

Turning to the waterfall, I painted it a soft, light gray and brought this color down into the pond. While the paint was still wet, I added some soft marks to indicate the dark areas of the falls and show the flow. Again, this lacked impact, because the lights of the falls were still surrounded by the white paper. So I defined the falls by adding the cool blue-gray plants in the right background. What I did was to first give the plants a middle-value color and then add the darks on top, articulating the pattern of the leaves.

Working on the rocks on the left side of the falls also helped to describe the cascading water and to accentuate the light yellow-green leaves in the foreground. I chose to paint these rocks a little on the warm side to contrast with the green plants.

At this point the painting was well established. My next step was to paint some darks on the left in the water, which made the leaves in the foreground advance. I also gave careful consideration to the overall pattern of light and dark shapes in the water, as these shapes can be critical in conveying the feeling of splashing or rippling water. Notice how the pond water is actually a mirror image

Water Rhythms, 20″ × 12½″ (51 × 30 cm), courtesy of the Esther Wells Collection

of what is directly above it, only it is segmented into horizontal bands. It took some care to preserve the lights that are so important in creating this effect, but painting around these areas gave the whole a fresher and looser look than Maskoid would have done.

At the very end, after softly suggesting the lath work in the background, I added the reddish-orange stamens of the flowers. Not only did this give information about the plants, but—more important—it added a few spots of hot color to a cool, soothing painting.

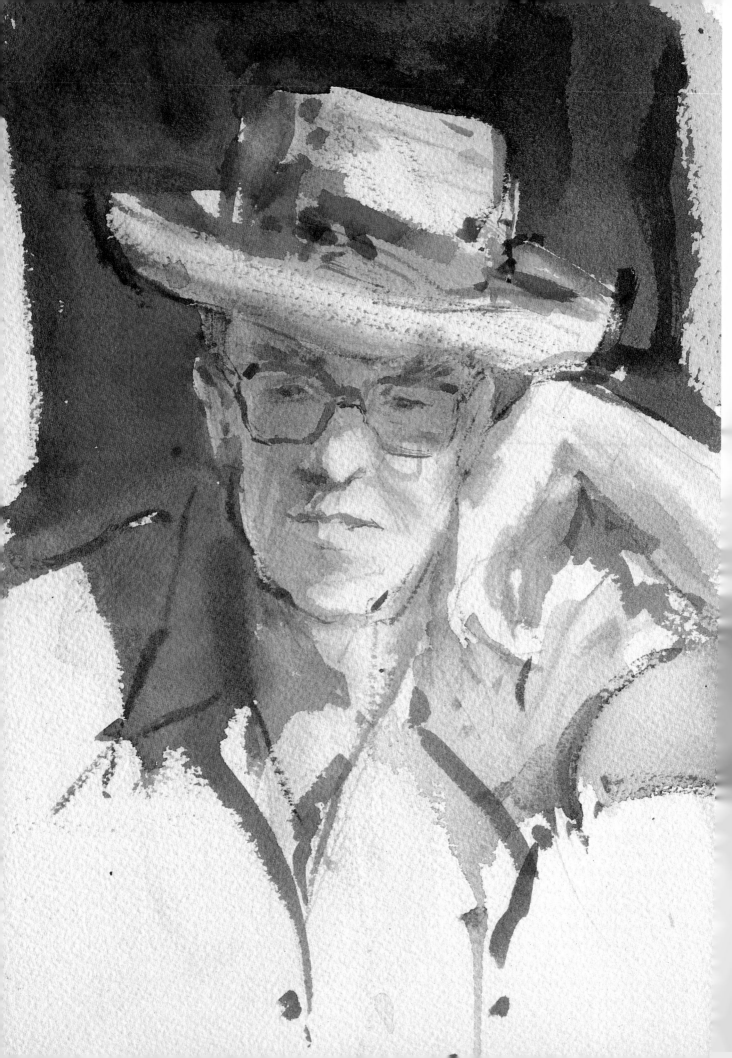

CHAPTER SIX

PAINT THE PAINTING

For many years painting was assigned the job of recording historical information and likenesses, as well as being expressive. During the last century the essential elements that "make" the painting—such as line, color, or shape—have taken on more importance. In part this is due to the invention of photography and the advent of abstract art. Both of these developments seemed at first to threaten traditional painting, but in the long run they may have elevated the art of representation.

At the beginning of this century Robert Henri, an American representational painter and an influential teacher, excitedly claimed that, with the emergence of abstract art, artists and collectors would have more choices—that both traditional and modern art could coexist. Well, they have coexisted, but not very peacefully. Abstract painters have been accused of not knowing how to draw, while more traditional painters have been accused of not knowing how to design a painting or express a unique vision. Recently, however, I've seen more cooperation among artists and a renewed interest in figure and landscape painting.

Still, there are artists who fall into the trap of just reporting—rendering all the details very carefully but not telling us anything on an emotional or design level. These artists are painting pictures, not paintings. (The same criticism could be made of some abstract artists who only follow fads and do not create.) It's sad to see these artists missing out on the excitement of creating. Maybe as youngsters they were praised for rendering and never bothered to develop further.

This chapter is intended to encourage you to relate the concepts we've already discussed to the execution of a painting. The idea is to go beyond just painting an object to make the painting operate on several levels. Looking at the way light and shadows fall across a figure, for example, you may realize that this not only reveals the form but also creates shapes, and it can offer a beautiful value pattern.

Essentially there are seven elements of design that artists use to create: line, shape, form, value (or light), color, pattern, and texture. While teaching, I'm apt to holler (or maybe just remind my students), "Don't just paint the subject; paint the shapes (or lines or color or whatever). Design the shapes."

Another aspect to be aware of is the paint itself. If you've been reading between the lines, you're probably already aware that the quality of the paint—its flow, for example—can be an important element on its own, contributing to the feeling of the painting.

And, of course, there's the artist's attitude to the subject, which plays a major role in the emotional impact of a painting. But that's the focus of the next chapter. For now, let's concentrate on how to make the basic elements of design a driving force in your painting.

Lee Morehouse,
10" x 7" (25 x 18 cm),
collection of Lee
and Sara Morehouse

Paint the Lines

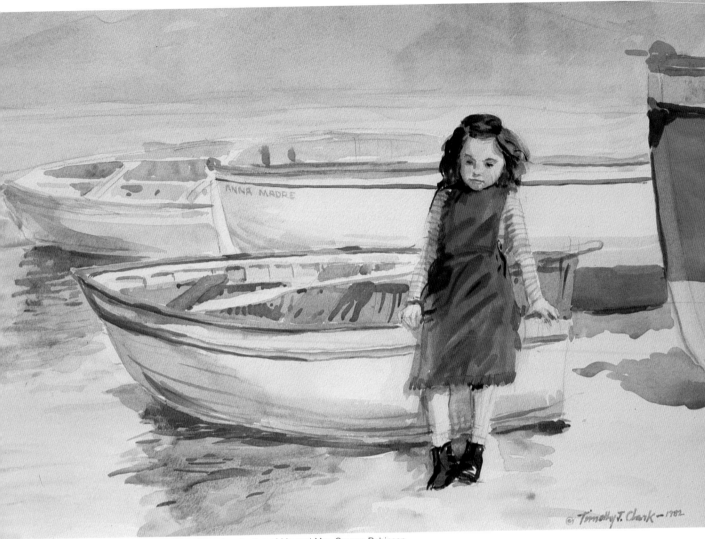

Anna Madre, Sorrento, 15" × 22" (38 × 56 cm), collection of Mr. and Mrs. George Robinson

Lines can be used both to explain and to entertain. Here a linear motif is set up by the bands on the boats, the stripes on the little girl's sleeves, and the edges of the shadows. Probably the most important line is the red one on the boat, which also runs through the girl's head and shoulders. This line helps to establish the girl's head as a focal point.

Fishermen paint lines on their boats for decoration, so it seems only natural to use the lines for their decorative impact in a painting. Notice, then, how the brushstrokes indicating the shadows on the foreground boat, the one the girl is leaning on, augment the linear beat. The boat on the right has a long, vertical shadow on

the bow, which also doubles as a decorative line. The point is that anyone, even someone like me, whose work is more shape-oriented, can use line as a decorative design element. It all depends on how you use what you see—what you choose to emphasize.

On another level, this painting conveys my reaction to Sorrento, an Italian village loaded with boats and children. After I'd made a good start on this painting, the little girl parked herself directly in front of me, in the hope that I would include her. Then, by the time I had committed myself to adding her, she left. Fortunately, I had established enough information to finish her from memory. Anyway, she makes the painting.

Palm trees have so many elements that it would be tedious to paint them all. Besides, you'd only confuse yourself and your viewer. For this painting, I narrowed my priorities to: (1) shape, (2) color, and (3) value, with some consideration for pattern as well.

Let's focus on shape—since that's the main element. Almost every shape in this painting can be reduced to a pie-like wedge. Whether we're talking about the clusters of fronds, individual fronds, or individual needles of the fronds, the basic shape tapers to a point. This common shape not only unifies what could be a confusing painting, but it also allows variety. There are large and small pie shapes, soft and hard pie shapes, dark and light and warm and cool pie shapes. Even the patch of blue sky falls into this theme.

Now take a look at the tall palm tree. If you focus on the entire collection of its fronds, it should—for a moment—read as a circular shape, before segmenting again into wedge shapes. This double-reading adds interest. Also notice the interaction between the dark shadow shapes of the fronds and the light areas, which they help to define. Try to consider every area in a painting. Even "negative" spaces—the spaces between objects—have a shape, and this shape can be just as important as the "positive" shape of the object.

All this discussion of pie shapes, however, may have given you the wrong idea. I don't expect anyone to walk up to this painting and say, "What nice pie shapes." The painting conveys my vision of a sunny California morning, with the luminous greens and bright oranges of the fresh fronds, and even the matted browns and purples of some dead fronds. I used shape to help organize and express my feelings about this scene.

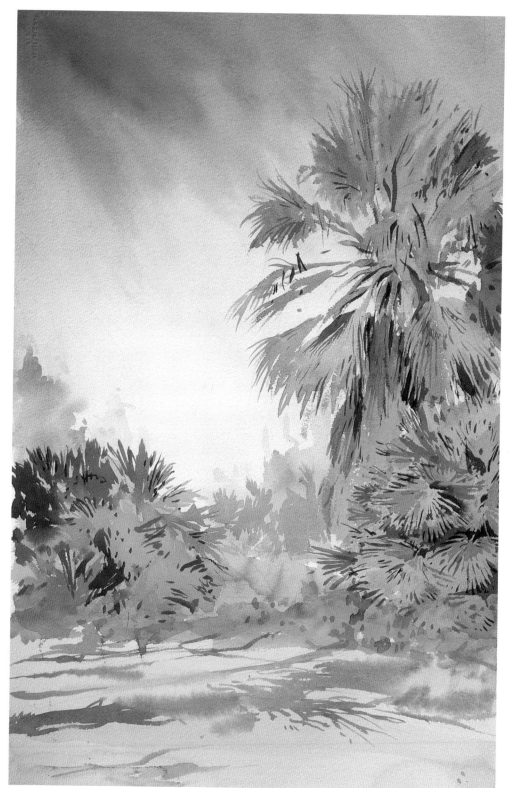

Palm Garden, 20″ × 13″ (51 × 33 cm), courtesy of the Esther Wells Collection

Paint the Forms

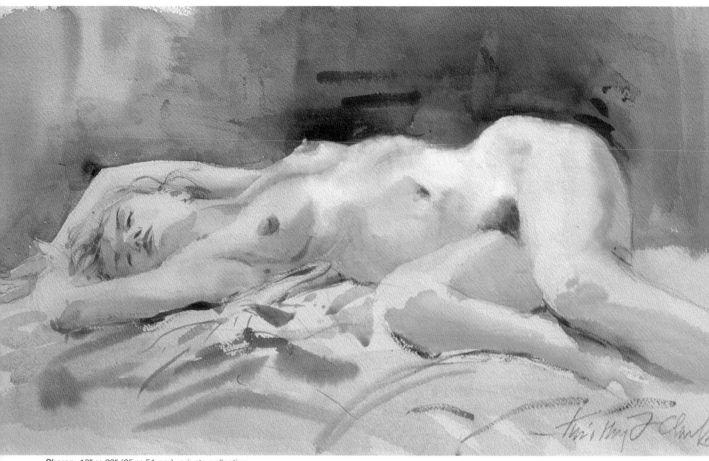

Sharon, 10″ × 20″ (25 × 51 cm), private collection

The twisting form of the model received the primary emphasis in this painting. Of course, the painting itself is flat—two-dimensional—so the form only suggests the sculptural quality of the figure. This suggestion is aided by the strong light and shadow: the top and left sides of each form are clearly revealed in the light, while the right side is in shadow. The dark background then augments the impact of the fully modeled figure.

Notice how the strong, simple forms of the legs and torso contrast with the forms of the arm and hands, gracefully framing the head. The head is then blocked in with sculptural simplicity.

It isn't only with figures that the form can dominate a painting and sustain our interest. Flowers, buildings, even old buckets have all had their forms featured in fine paintings. If a form is of great interest to you, paint it.

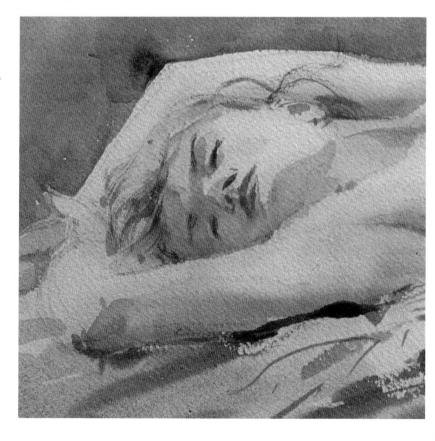

Although it is possible to work with just one value, the creative possibilities expand when more elements are introduced. In this scene the local color of the trees was much darker than the local color of the white chair, but the trees were in bright sunlight and the chair was indoors. I therefore pushed the values, making the chair darker than the trees. Similarly, because the polished mahogany table reflected the sky, the top is close to the sky in color and value, but the front and parts of the legs are painted with darks. Even the white flowers in the vase appear darker than the bright sky.

To get all the values in the proper relationship, I had to squint. The overall effect that I wanted was very sunny, cheerful, and formal. I did most of the painting in one sitting, working about four hours.

It's important to mention that I was at the home of these collectors to paint their garden. But, as beautiful as their garden was, I was drawn to this view out the window. Success is more likely to come from painting what interests you.

Jeanie's View, 30″ × 22″ (76 × 56 cm), collection of Gordon and Jeanie Frost

Paint the Colors

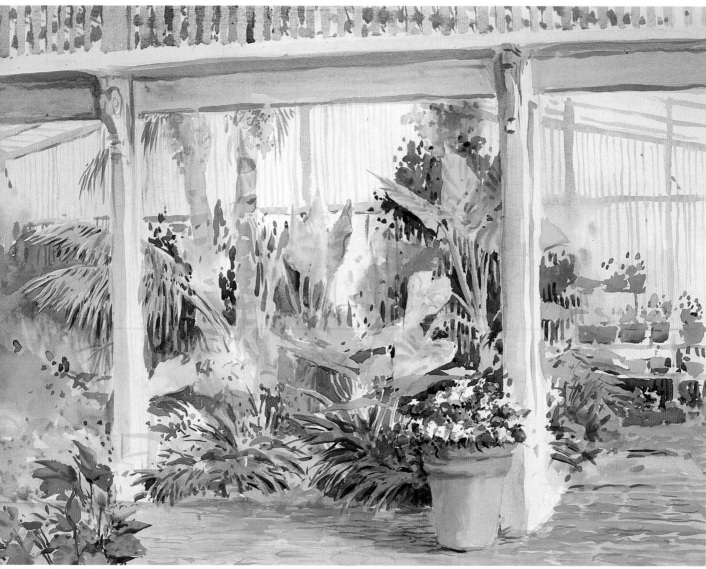

Afternoon Glow, 22" × 30" (56 × 76 cm), collection of Mr. and Mrs. Weston

There is so much to be said about the role of color in painting that each artist could write a book on his or her personal approach. As we've already seen, color can be used to augment the feeling of light. And color can help to express the mood of a subject. I don't think I need to sell the idea of using color as the dominant design element.

This painting presents just one of many possibilities in the use of color. When I painted this open-framed structure, the sun was getting lower in the sky, giving a last bath to light on the plants. To capture the glowing color, I grouped the colors into two large families: a relatively warm orange-yellow-green family and a cool blue-purple family.

As I put the colors down, I was always thinking of relationships, playing one area against (or with) another. Since I wanted the bright yellow-greens and oranges of the plants to dominate, I designed the touches of blue sky and the cool gray-purple of the architecture to complement the plants and set them off. Notice how the dark accent colors in the background have each been mixed to bring out a color in the foreground. Also notice how the cool blue-green above, just right of center, makes the color on the broad-leafed plant come to life.

In addition to the interaction of warm and cool colors, there's the role of color intensity. As the objects recede in space, the color intensity diminishes. The single large pot in front is much brighter than the series of pots on the back wall. This muting of the color teams with the change in scale to make the illusion of space convincing. A similar shift can be observed from the horizontal support in front to the lower-contrast horizontal in the distance.

Now take a look at the bright red accent in the lower left corner. This color both anchors the scene and provides us with a starting point into the painting. That the color represents some cyclamen growing in the foreground is secondary. If you let your eye be guided by this red, you're taken right into the heart of the painting.

Don't be afraid to experiment with color, expanding its range and using it in "unrealistic" ways. Here, for example, I didn't model all the plants—instead, I left some areas flat, so the color would dominate. Occasionally, I will use a pan set of watercolors or a hot-pressed paper to push my color. For me, pan paints seem to discourage color mixing, leading me to use brighter colors. With a hot-pressed paper, the surface is smooth, with no texture, so the colors often seem more solid and brighter.

Under the Patio, 32″ × 42″ (81 × 107 cm), collection of Jackie Davison

Pattern is all around you if you look for it. The leaves on a tree, for example, can be reduced to a pattern. A scene like this, with its tile floor, lath roof, and gridlike cast shadows, can be a reminder to wake up to the potential of pattern.

One thing this painting shows is how to take the ramifications of pattern beyond the obvious. The shadow pattern on the wall conveys the flickering quality of light. The doors then continue the rectangular theme, while changing the scale and moving the eye in a different direction. Now compare the white door against the dark background with the dark door silhouetted in the distance. In this way you can read the pattern in a positive and a negative manner. Turning to the striped umbrella and the shadow across the

tablecloth, here the pattern is not only continued, but it also reveals the form. The backs of the black metal chairs then provide a further variation on the pattern.

Because pattern is such a vigorous graphic element, I deliberately designed some areas of relief. The bright blossoms of the foreground plants momentarily overpower the pattern, attracting attention in their own right, while the soft shapes of the vegetation in the distance provide a welcome rest. I even rewet the tile and softened it with a brush, so it wouldn't compete quite so boldly.

When the opportunity to create with pattern presents itself, don't miss out. But remember to play it up and down in keeping with the overall design of the scene.

Paint the Textures

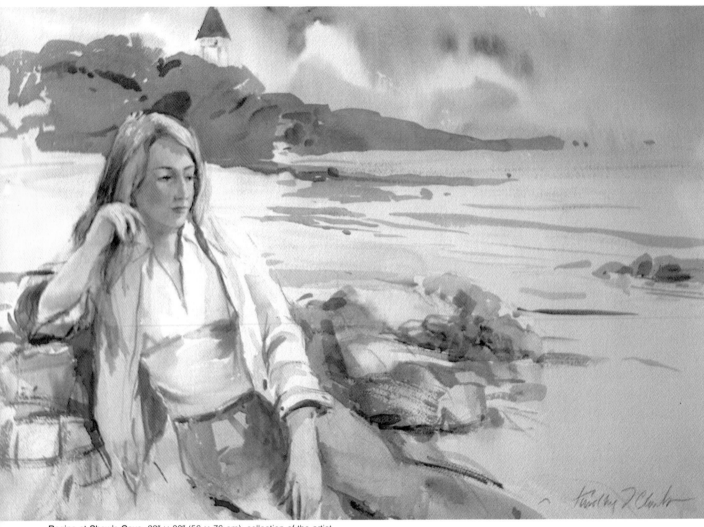

Regina at Shaw's Cove, 22″ × 30″ (56 × 76 cm), collection of the artist

So far the paintings I've discussed have been dominated by the element I was describing. Texture, however, doesn't lend itself to that kind of prominence in my work—although it might in yours. What I do find is that, since watercolor is primarily a medium of washes, texture provides a useful contrast to the washes.

The areas that are alive and vigorous with texture in this painting are the rocks, hair, and part of the water. Notice how the rocks contrast with the sand, pants, and jacket, while the hair texture contrasts with the face and the hands. Even the clouds in the distance seem to benefit from the texture of the paper that shows through in the distant water.

To paint the rock textures, I loaded my brush with fairly stiff paint (using a dark mixture with little water) and dragged the brush sideways across the paper. For the hair, I used the technique described on page 77, with the bristles of my brush sprayed out in a comblike form. In a sense I "combed" the hair, with my strokes following the contour of the head. In contrast, for the drybrush effect near the horizon, I used two sweeping strokes, so the paint just hit the "hills" of the paper.

Keep in mind that texture does not need to be tied to the subject. It can be an abstract element, contributing to the design, as well as a tool for rendering form. Use it to add punch to your paintings.

First Evening in Scotland, 9″ × 12″ (23 × 30 cm), collection of the artist

In this little color sketch, the handling of the paint is the main graphic attraction. As the title indicates, I painted this on my first evening in Scotland. What inspired me was the dramatic, sweeping sky. I thought, however, that the sun was almost down and there would be only minutes to paint. To my delight, the sun in the far north takes its time; it seemed to hang there for a few hours until I completed my sketch. Yet all the time, honestly believing darkness would descend any moment, I really flew with the paint.

Here the execution was far more important than the drawing, composition, or color scheme. I looked at the subject and responded with paint. Notice how the wet sky not only changes from white to orange to deep purple, but also changes from a series of soft,

grainy strokes to long, sweeping strokes. Now compare the opaque bright orange center of the sun with the more transparent sky and clouds around it. The fields and stands of trees also offer an exciting interplay of different paint qualities, with washes and strokes of transparent and thicker, pasty paint. Altogether that evening it seemed I was able to get the paint to give an inspired performance.

Although the handling of the paint can carry a painting, there is the risk of using it as a crutch, manipulating it cleverly to make the painting look good. Give the paint a job—a mood to express— and demand an honest interpretation. That way the handling of the paint will be integral to the painting, not just a show of virtuoso technique.

Chipping Campden, 22'' x 30'' (56 x 76 cm)

FINDING WHAT'S IMPORTANT TO YOU

A personal approach—that special vision that each artist brings to his or her work—should be an integral part of every artist's development. I am always puzzled by students who inform me, "I will get my skills first and then in a few years I'll be ready to create." These people usually never stick their necks out and paint. But I'm also wary of students who say, "I think I can paint—I'll learn to draw and find out about color theory later." They aren't doing themselves any favors. Still, if I were to bet on one of these two groups, I'd bet on the second, because they seem to have something to say and that is what it is all about.

How do you give your paintings a special look that is just yours? A lot of it is honesty—discovering a subject that *you* want to paint, determining *your* attitude toward what you see, finding the color combinations that *you* prefer. In addition, once you master the basic techniques and as you continue working with the medium, your brushstrokes will take on an individual quality, much like handwriting. It is senseless to try to copy another artist's, even a master's, "handwriting" because it will block your creativity.

The best way to let your personality come through is to paint regularly and become comfortable with the medium. Study a group of your paintings and look for similarities in both the strong and weak areas. Be aware of your brushwork and design responses. But, most important, ask yourself what you want to communicate to others with your painting.

Often I hear students complain that their work does not look like so-and-so's. Yet they may actually be on the path of something new, and so-and-so's work may be safe and easy (and ultimately boring). Have faith in yourself. If the painting honestly expresses what you see, it may be better than you think.

Looking at the work of a great master can be an eye-opener in this regard. While in the Rijks Museum in Amsterdam, I was struck by the nerve of Rembrandt. Many of his paintings were incredibly daring for the time—it took a lot of courage to present them. A lesser artist might have blotted out and fixed some of the loose, painterly strokes as a "mistake." Rembrandt, however, was comfortable enough with himself to share his handwriting and his soul.

Discovering a Subject

When it comes to subjects, the entire universe is fair game. Artists have created works about everything imaginable. As a start, it's a good idea to ask yourself, "What part of my home do I enjoy the most?" It may be the kitchen, with its pots and pans; or the garden, with its plants; or the view outside a window. A sewing area, tools in the garage, sports equipment, or a pet are other possible subjects.

When you know and enjoy a subject, it is easier to imbue a painting of it with meaning beyond simple reporting. One of my beginning students who loved to cook had the good sense to incorporate her stove and kitchen utensils into her drawings right from the start. She designed the familiar pots and pans into wonderful compositions. Painting the kitchen gave her the chance to express not only the simple (but often overlooked) beauty found in the home, but also the warmth and love often found in the kitchen.

Drawing and painting around the home, or another familiar spot, will help you to express yourself—although you may need to experiment with several different subjects, groping for what is meaningful to you.

Some artists like to develop a particular subject or theme in a series over many years. Winslow Homer, for example, did numerous early watercolors of fishermen's wives. Pablo Picasso, Henry Moore, and John Marin—three very different artists—also worked in series.

While you are developing as an artist, it may seem difficult to maintain interest in one direction for more than a few pieces. But later you should be able to attack an idea from various angles while maintaining your own identifiable style. One potential danger of working on a theme, however, is that the work can become stale if you don't grow with each painting. It's important to keep experimenting with other directions.

In sum, the mature artist is able to paint in an individual style and at the same time break away, continually exploring new approaches. A good example is found in Childe Hassam's variations of flags hanging on Wall Street in New York, which he interspersed with paintings that he did on travels in Cuba and Europe.

It's tempting to think that on your first project you'll do a masterpiece—but that's just silly. Start simply, perhaps with something organic from the kitchen, like the radish and walnuts here. First make a simple line drawing of just one object. Be conscious of the shape of the object. Then mix the colors and paint the shapes with a simple wash. You may want to mix a darker version of the same color to add a few accents, but don't worry about careful rendering. Your first painting should be little more than a colored drawing. Repeat this, adding another object to make a small composition, as I did with the walnuts.

If that goes well, then try adding darks in the background and a few cast shadows on the table. Can you go on? Sure, but decide to stop. These are simple little statements, meant to show you what a minimum for watercolor can be. Someone once told me that you can stop at any good point, but you can never finish.

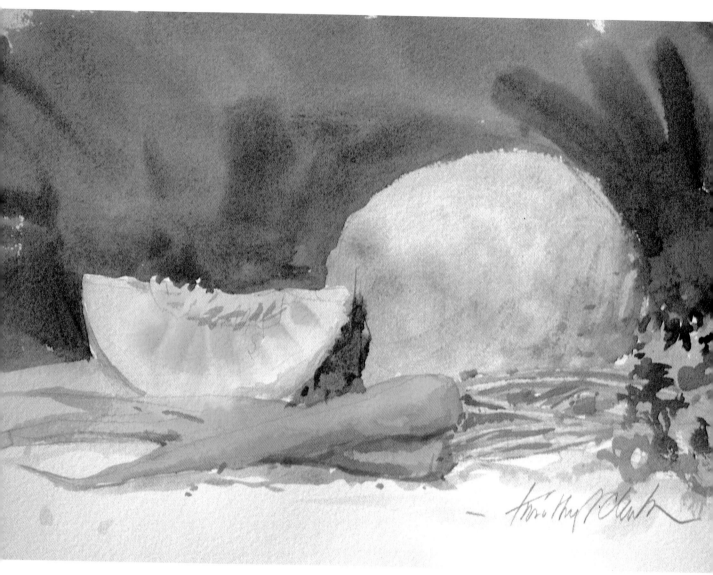

One of my own teachers, Joyce Trieman, gave me this advice: "Always paint what is important to you, because if it is appreciated, you will have to do a lot of it." Of course, there's a danger here that you may become stuck on a theme because of demand. It has been said of John Singer Sargent's portraits, for example, that the demand was greater than his interest in repeating variations, and that he felt the pain of painting pieces he had lost interest in.

Another pitfall is using a subject that is a gimmick or fad. Although there may be a temporary appeal, the work will probably not succeed because it isn't nourished by honest motivation. An artist who is not sincerely attracted to a subject may run out of gas before the idea is really devel-

oped, and the painting will then show a lack of commitment.

On a personal note, I have painted gardens as a theme for several years. As I grow as an artist, the gardens I paint have also grown and changed—making for new discoveries. My favorite places seem to refresh themselves.

At the same time I regularly paint local landscapes, portraits, and figures, as well as an occasional still life. For variety, I like to travel across the United States and in Europe, painting in small villages. I find it very stimulating to be faced with subjects I have never seen before. Knowing how to create in familiar settings helps me to create in foreign settings. An artist's studio, I believe, is wherever the artist happens to be.

Now dig deeper in the veggie bin, or set up a still life with tools or fishing gear—whatever you like to look at. Add a few more elements to your subject and more complexity to your painting. Start with a simple sketch and a simple wash; then keep on going; as I did here. But remember: this isn't the ultimate painting of your life—just a study to start you toward your best.

Notice how the dark background brings out the cantaloupe and how the wet-into-wet treatment of the cantaloupe meat plays against the hard contour of the fruit. To suggest the cantaloupe texture, I dropped manganese blue into the grain of the paper. For the green carrot stems, I used scraping.

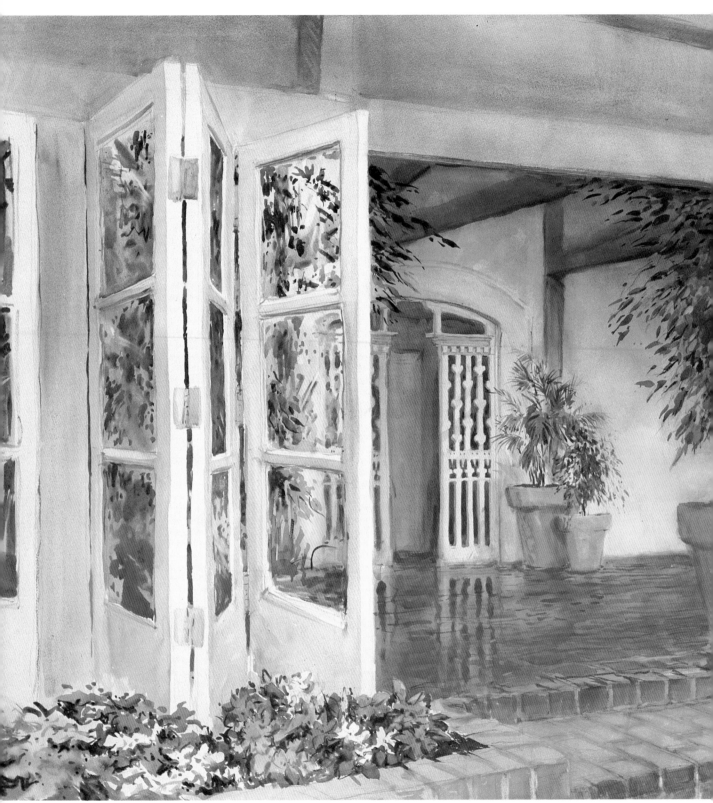

Grand Entry, 34½″ × 44½″ (68 × 113 cm), collection of Mr. and Mrs. Kemp

These two paintings show how the interpretation of a subject can change over time. Initially I was interested in setting up visual passages for the eye to travel through, as my title for the first painting suggests. This idea continued to intrigue me, so over the years I have continued to reexplore it with the same subject.

Passages III, the earlier work, is much more formal. The French doors are pushed to the side, opening up our entrance into the painting. The strong directional pull of the tiles then takes us to the play of light on the back wall and the decorative door frame, which is the center of interest. Both the plants on the right side and the linear black chandelier hanging in the center act as counterpoints, leading us away from the door in back, so we explore the rest of the painting too.

In Grand Entry the mood is different. Instead of the earlier frontal view, we see the scene from

an angle, setting up a zigzag movement into the painting. The flowers and steps lead us into the painting, but the doors play a dual role: opening up to invite us into the center, yet distracting our eyes with their many reflections, which act as several little abstract paintings. Notice that here the elaborate arched doorway has been moved off-center and is partially hidden by the French doors. Although this doorway is still a focal point, the movement toward it is far more complex than in the earlier painting.

In repainting a subject like this, I am always afraid of repeating myself, so I deliberately try to make the paintings change and grow. Often, however, I do paint a small version of a scene before attempting a major work. This kind of preliminary study allows me to experiment with my ideas and plan what I want to do. It is a stepping stone on my way across the river.

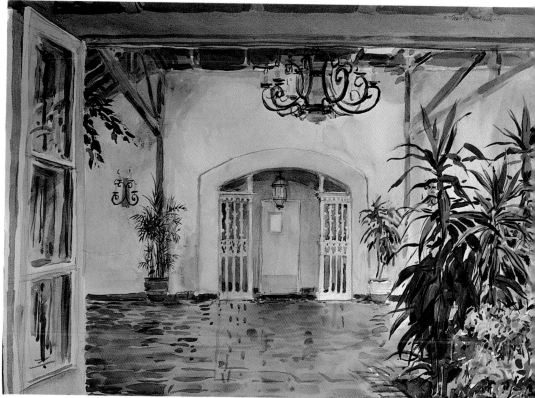

Passages III, 22″ × 30″ (56 × 76 cm), collection of Mr. and Mrs. Charles Elliott

Arboretum, 22″ × 15″ (56 × 38 cm), collection of Dr. and Mrs. George Krmpotich

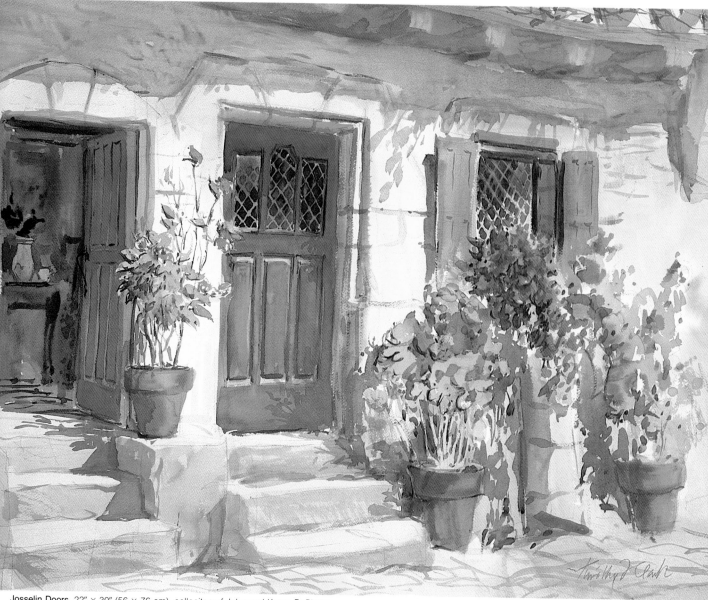

Josselin Doors, 22″ × 30″ (56 × 76 cm), colleciton of John and Karen DePietro

The painting on the left shows a spot I've returned to several times over the years. Each time I've seen it differently, adding something new to my painting or moving to a new angle. Here I used a different kind of paper, which encouraged a different creative response. Also, it was a humid, misty day, which meant my washes stayed fluid and open to change for a longer time—again, encouraging a different approach.

It can also be stimulating to paint in a place you've never visited before. With the painting above, the back doors to the Josselin castle in France caught my attention. I was especially taken with the wooden panels and leaded glass in the middle. After looking at these doors for several days, I finally found the right light to paint them in.

Although the setting is definitely different, you've probably already noticed similarities between this painting and other paintings of mine in the book. In many ways it's a variation of one of my garden paintings, with the open door and strong light and shadow. Even a detail, such as the shadow of the vine across the top, reveals my

interest in the intertwining of manmade architecture and nature.

I don't remember all the steps of this painting, but I probably began by running a golden wash of cadmium red and new gamboge over the paper. Next I defined the planes of several forms, including the steps and door jambs, by adding a darker value. For the leaded glass windows, I first laid in a cool gray wash, and after that had dried, I painted in the dark panes, varying the colors from reddish to bluish darks. With the wood panels of the doors, I worked from light to dark, building the door in stages. Notice how the interplay of lights and darks sculpts the panels, giving them a three-dimensional feeling.

I wasn't able to finish this painting on location, so I took a photograph (which proved to be almost useless). When I got home, I made up the interior seen through the open door and added some final adjustments to the painting. For this I relied on my memory, although the photo did serve as a visual "click." Actually, I'm not at all against using photographs occasionally (see page 119).

Expressing an Attitude

Art is essentially about communication. As you look at your subject, ask yourself, "What is it that I want to say about this still life or figure or landscape? What interests me in it, and what would I like to help other people see in it?" You might simply want to capture the beauty of a particular moment. Or you might want to communicate the order—or disorder—you see in the world around you.

One concept that has intrigued me for years is man's relationship with nature. Almost all landscape painting, in my opinion, relates to this idea. Nature may, for instance, be depicted as a quiet, ordered world with trees peacefully embracing a village. Or it may be shown as a destruc-tive force, with stormy skies and raging winds. To me, these different represen-tations suggest different attitudes on the part of the artist. One artist may see the world as primarily harmonious, while an-other may be more focused on discord. Both views, of course, are valid—they're just different.

An artist's attitude toward a subject can have a major effect on both design and color choices. If, for example, you want to convey the quiet peacefulness of a gar-den, it's unlikely that you'd use a lot of harsh diagonals or jarring colors. The idea is to be aware of these design elements and to make them work for you, express-ing what you want to say.

Bellosguardo Rooftops, 15″ × 22″ (38 × 56 cm), collection of Mr. and Mrs. George Robinson

The Tempest, 22″ × 30″ (56 × 76 cm), courtesy of the Esther Wells Collection

The inspiration for this painting came while I was looking out the window of the house my grandmother grew up in. To me, it seemed a good example of man and nature in harmony. The walls and the tile roofs were the same color as the surrounding soil because they were made from the surrounding soil. The foliage complemented and embraced the architecture. And the slightly slanted roofs echoed the gentle slope of the surrounding hills.

Even if the subject shows harmony with nature and you copy what is in front of you, that doesn't mean your painting will express this idea. You must take an active role in designing that harmony into your picture. Notice here, for example, how I've emphasized the warm earth colors of the buildings and how I've used soft edges and a blurring of form in the background so the village and the landscape seem to merge.

Even when I'm painting an impending storm, I tend to show a harmonious relationship between man and nature. The road leading into this village is inviting, and the buildings, sheltered by the trees, seem comfortably nestled into the landscape. If you block out the top half of the sky, you'll see that the foreground is quite sunny, which it was when I started. It's only the ominous clouds near the top that threaten the tranquillity of this scene—and they almost ruined my painting. If you look closely you can even see raindrops near the upper right corner. The paper was so wet that when we walked to a barn for shelter, I had to carry it flat while my wife held a drawing board over it to protect it.

Discovering Your Colors

In addition to brushwork, your choice of colors is part of your signature as an artist. Each of us probably sees color slightly differently, and we each have our own individual preferences. But the idea, once again, is to use color to express what you want to say.

How color preferences become woven into our lives is hard to explain. The origin of a particular like or dislike is often long forgotten. You may be attracted to a certain red because of a special shirt you had when you were a youngster. Or you may be repelled by a certain green because it reminds you of the principal's office in grammar school. Whatever the case, try not to let these preferences become blind spots, preventing you from exploring a full range of color possibilities.

Society and culture also influence how we "read" color, providing us with a more universal color language. Certain colors have come to symbolize specific events and seasons—for example, blue for the birth of a baby boy and pink for a baby girl, or red and green for Christmas and purple and light green for Easter. Psychologists and decorators compound this with talk of the emotional impact of color. We are likely, for example, to associate red with passion and danger and blue with calm and spaciousness.

And then there are all the aesthetic principles of color. There's the idea, for example, that warm colors advance (pulling the eye forward) while cool colors recede (pushing the eye back). Or you might refer to my discussion of color in relation to light (page 70).

How do you begin to organize and make your own color statement in the midst of all these influences? How do you decide which rules work for you and which don't?

There are no set answers—the best I can do is to provide you with a few, simple guidelines.

First, never discount a color: all colors have potential. It is possible to make any color look good. When I was in art school, one of our assignments was to take what the instructor called a "gawd-awful color" and mix two new colors that made the problem color look pleasing. Not only was it possible, but—most amazing—the "solution" colors differed from student to student. In other words, there were several solutions that worked.

A second guideline is related to the idea that all colors are potentially good. If you use a color deliberately in a well-designed shape and its value is appropriate, then the color has a chance. Many times the problem is not the color per se but its value or handling. Often I've seen students introduce a color that is out of the ordinary, but then they handle the color tentatively, overworking it, and they don't get the value right. Instead of creating an identity between the shape and the color, they create confusion. If you choose a color, be definite about it.

As you explore colors and try out different combinations, you will gradually discover particular combinations that work for you. This doesn't happen overnight. It's more that, as you continue to paint, on certain days the color just naturally falls into place. Certain color combinations stand out as more intriguing and "right" for you. Once you recognize these tendencies, it's easy to play with variations and develop new combinations that still seem personal. This is not to say that you simply repeat the same scheme over and over. The colors must remain meaningful in every painting.

This painting makes use of one of my favorite color schemes: a predominantly gray painting with one intense color—in this case, yellow. This scheme has a lot of room for variation, as it is possible to create many different colors of gray (blue-grays, purple-grays, green-grays, yellow-grays, and so on) without disrupting the impact of the intense color. For this subject, the scheme seemed particularly appropriate because the grays helped to tie the tiles, pot, and wall together, keeping them secondary to the orchids and lemons. Imagine the confusion if every object were painted in a totally different, unrelated color—you probably wouldn't know where to look.

Orchids and Lemons,
20″ × 12″ (51 × 30 cm),
private collection

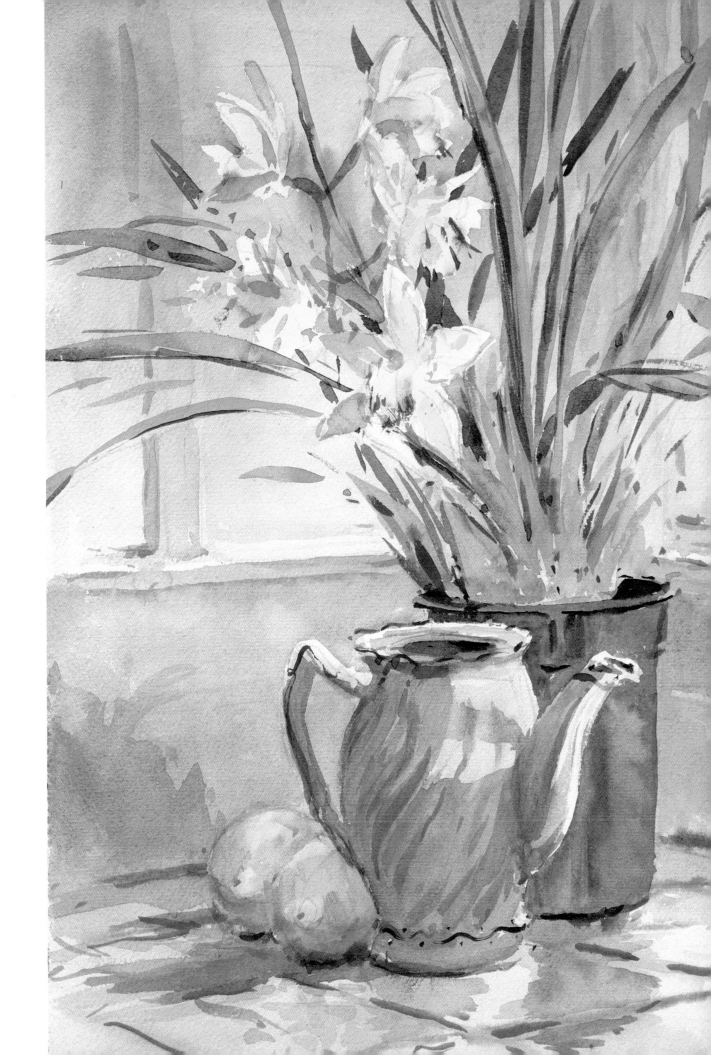

Discovering Your Colors

These three paintings—all done as demonstrations
during my Hawaii watercolor workshops—show
the changes in my personal color approach over a
five-year period. Granted, mood and weather
were factors in my color choices, but there is still
a definite evolution in the color style. That
doesn't mean that the most recent painting is
necessarily the best. If someone asks me,
"What's the right way to paint a painting?" my
answer is that there are many right ways—let
your approach develop from your vision.

Let's begin with Kona Palms, one of my first
successful paintings of palm trees. Because
palms are such a challenge to paint, I decided to
narrow my choices, restricting my color scheme
to silvery green-grays. Even the greens and yellows
of the palm fronds were knocked down to this
range. Limiting the color in this way made it
easier to control the values and allowed me to
concentrate on shape. At the same time the green-
gray color scheme seemed appropriate to the mood
of this ancient beach with its tall, shady palms.

In the second painting, Puako Road, the subject
is somewhat different. Besides exploring the
beauty of the foliage, this painting carries a
healthy dose of nostalgia, with the old car in the
drive, the rural mailboxes, and the two boys
walking toward the beach. The light here is
stronger, giving clear shapes to the cast shadows,
especially in the foreground. Overall there is an
expansion of elements, inviting a wider range of
color. Here there is a lot of yellow and even
some red accents in the foliage. Also notice the
color in the shadows. The purple and blue-green
shadows repeat the fronds of the trees and help to
show off the yellow-greens and warm tans in the
foliage.

The final painting shows a stand of palms on a
hot, sunny beach, near an ancient freshwater
fish pool. The expansion of the color range and
intensity is very apparent. It is not so much that
the palms have changed, but that my own direction
has become clearer. Here the combination of
greens, swinging from yellow to blue, with the
orange accents makes a vibrant, splashy color
statement. Notice how the more distant palms are
unified in color and rely heavily on their
silhouettes for definition. This provides relief and
at the same time ensures that the focus of
attention is on the front tree.

Kona Palms, 22″ × 15″ (56 × 38 cm), collection of Dr. and Mrs. G. William Mahlman

Puako Road, 20″ × 25½″ (51 × 66 cm), collection of Mrs. Nellie Reeves

The Robb Palms, 22″ × 15″ (56 × 38 cm), collection of Bill and Gretchen Robb

Discovering Your Colors

Spring Garden, 22″ × 17″ (56 × 43 cm), collection of John and Karen DePietro

This painting continues the color interest I described in Spring Garden, *but it also shows a slight change in direction. Over the years I have looked for ways to step away from green. It's not that I dislike green, but a little can go a long way, balancing a lot of red. As someone who paints outdoors quite a bit, I know that nature serves up big portions of green. I've found, however, that flowers, bricks, tiles, and sky can be wonderful antidotes for too much green.*

Here I used an interesting technique on the red flowers. First I painted the entire plant area with a pale wash of cadmium red and Winsor red. Then, working into the moist paint, I added some light greens. As I continued to model the leaves and the flowers, I alternated between darker reds and darker greens. The cool pink flowers on the left were painted in the same way, only I kept them simpler, so they wouldn't compete with the red flowers.

This painting is a relatively early one from my garden series, yet it already contains many of the themes that continue to fascinate me. I find the splashes of greens and blooms interspersed with architecture an appealing and peaceful combination, bringing together the organic and the manmade. This painting also shows my interest in the interplay of reds, greens, and grays. Notice, for example, how the warm bricks balance the greens of the plants and how the neutral gray of the architecture acts as a buffer between the two complements. There's also a contrast between the wet, loose handling of the plants and the tighter control of the railing.

There's a special touch in the bricks. When the front edge was still wet, I added some intermittent cadmium orange accents. Not only does this give a sense of random change in the bricks, but it suggests the glow one brick in the sun gives off to another, adding to the feeling of light.

The Portal,
22″ × 15″ (76 × 56 cm),
collection of Chris Hopper

114

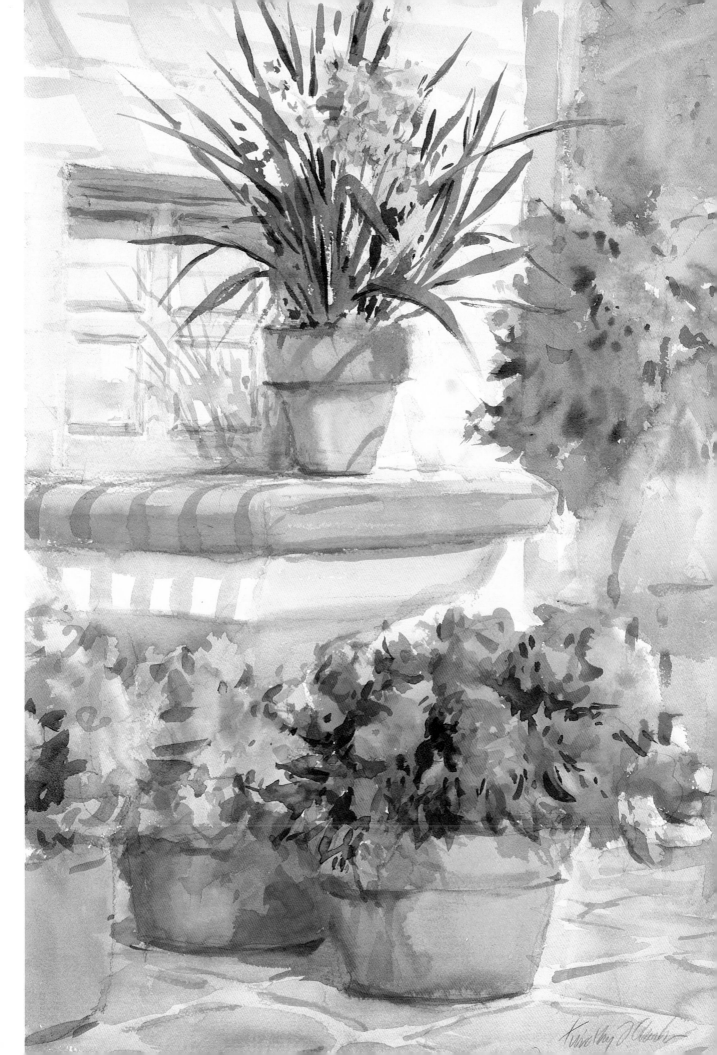

Disciplining Yourself to Paint

If you paint, or draw, or sculpt, or produce any art, you are an artist. You may be a great artist or a student, but to call yourself an artist, you must produce. If you only think about drawing or painting, but never do anything about it, you are not letting the artist in you live. Thinking about painting is little better than thinking about exercising.

Each artist's routine will vary, but the activities must be regular. That is where the difficulty sets in. Imagine that you are in your studio area, all set to paint a masterpiece, but you're not quite sure where to start. Suddenly you remember that you never sent a thank-you note to your aunt for the birthday gift she sent. You stop to write it and never face the blank paper.

One way to solve that problem, besides keeping up on all your thank-you notes, is to plunge in. If it seems too awesome to tackle a major painting, then just make some small sketches, using pencil or washes on paper. But make certain that you produce something during your studio time. Once you start doing something, it becomes easier and easier to continue.

The point here is to work whether you feel like it or not. A sign of a true artist is that he or she acts responsibly, taking painting seriously as a job. Sometimes I do my best work on days when I do not initially feel like painting. You may feel that you're just carrying out a routine, but you can be surprised out of the blahs once you get going.

To keep everything flowing, I make use of what I call "the sourdough syndrome." Just as the prospectors always kept a portion of bread dough for the next batch, I try to keep paintings in various shapes at all times. If I start one painting and the light changes or I get stuck, I can take a different painting out to finish it. The next day I will start another work and finish the one begun the day before. This method works well on location or in the studio. It not only keeps my creative energy alive, but it also helps prevent overworking of a painting.

Being an artist means you have only one boss: yourself. Enjoy that freedom, but remember to *be* a boss and get yourself started. The important thing is to keep painting. That's the best way to grow as an artist.

Day's Last Glow, 22″ × 15″ (56 × 38 cm), collection of Mr. and Mrs. Dwane Prescott

I teach both day and night classes on Wednesdays, but I have a few free hours in the late afternoon. I started the painting above one afternoon and soon realized that what I wanted to capture was a particular lighting condition that lasted a short while, for about thirty to forty-five minutes. I got caught up in this painting challenge, and I came back for several sittings at the same time on subsequent days.

Eating breakfast in a hotel in France, I was anticipating my day's painting when it started to rain. Rather than bemoaning the weather and excusing myself from my studio time, I stayed in my seat and painted the table and the view through the window.

If you are having trouble getting started, why not paint your own breakfast table? Take whatever you have—a coffee cup, plates, maybe a piece of fruit—and paint it as it is. You don't need a grand subject to make a painting. Pierre Bonnard made wonderful paintings of ordinary breakfast-table scenes. The only thing that will help you become an artist is regular creating.

French Breakfast Table, 22″ × 15″ (56 × 38 cm), collection of Dr. and Mrs. Joseph Hart

Disciplining Yourself to Paint

Before doing this large painting, I tried out my idea in two smaller versions of the scene. By the time I took up the large sheet of paper, I knew where I was going, so it wasn't as intimidating as it might have been. Specifically, I was able to get a handle on the shapes of the plants in the middle and make them a more powerful design elements in the painting. Also, in my initial version there's a fern with soft edges on the upper left, but in the final version I substituted a banana tree from another part of the garden because its rhythmic shape was more in keeping with the rest of the painting.

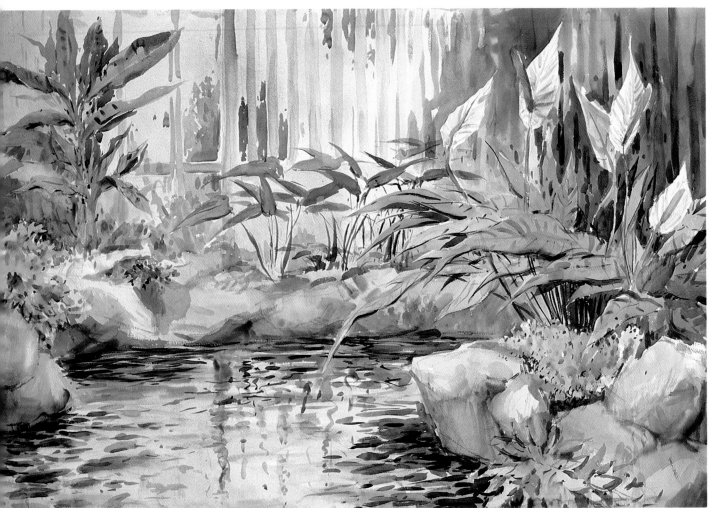

The Koi Pond, 29½″ × 44½″ (75 × 113 cm), private collection

This subject is certainly out of the ordinary for me. While I was traveling in Italy, these roosters intrigued me, but they did a lousy job of sitting still. Anyhow, I didn't really have time to stop, so I took a photograph as a reference and later painted this in my studio.

As I mentioned before, I'm not opposed to using photographs, although I usually paint from life. Sometimes a photograph can expand your painting choices, allowing you to "still" a moving subject like these roosters. The idea, however, is to use the photo as a reminder, not to copy it slavishly. If the photo is your own, of a place or scene you have strong feelings about, you're more likely to interpret it in a personal way, so the painting reflects your own personal vision.

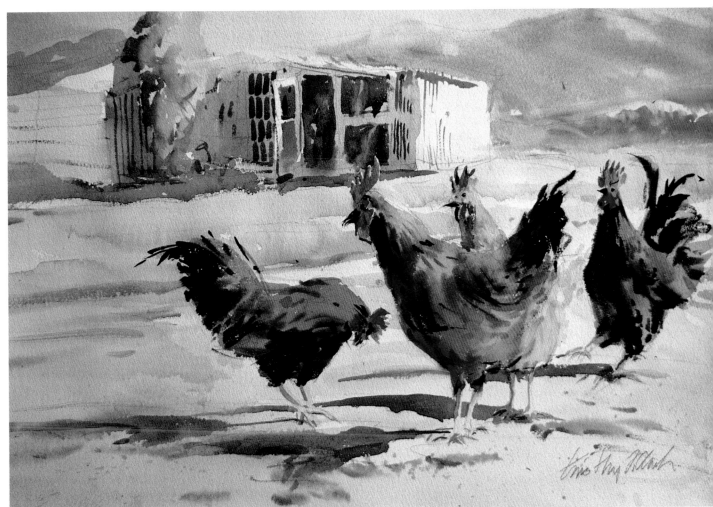

Chianti Roosters, 13″ × 19″ (33 × 48 cm), collection of the artist

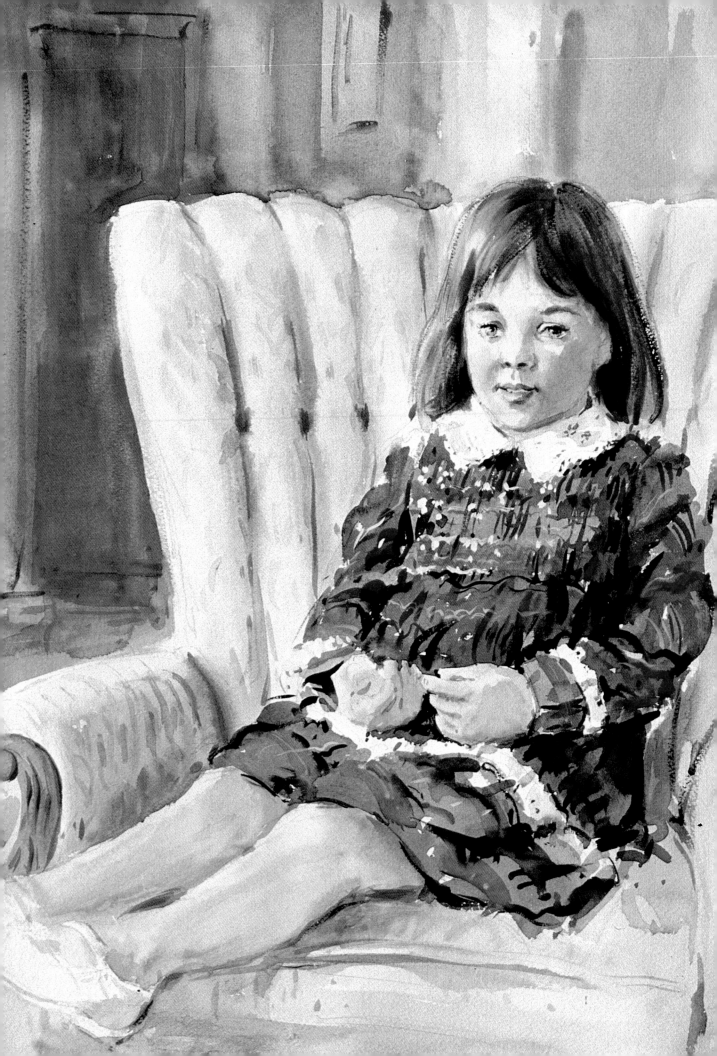

THE WORLD AS YOUR STUDIO

At the mention of the word *studio,* you may think of a small attic room in Paris or an old factory loft in New York. Or you might imagine a vast production hall with dozens of workers, as in Peter Paul Rubens' legendary studio. But these are just three possibilities. Studios, like artists, come in all shapes and sizes.

One of the wonderful things about working with watercolor is that you can set up your studio in minutes and tuck it away again just as fast. The fact that there are no fumes with watercolor, as there are with oil painting, makes almost any part of your home an acceptable location for a temporary studio. You can paint at the kitchen table or on your lap, while sitting in the living room. And you can also easily carry your equipment outdoors and on trips.

I've worked in many different kinds of studios, both big and small, inside and outside. This chapter looks at three main types of studio: the instant studio (the kitchen table, for example), the outdoor studio, and the permanent studio. In each case I offer suggestions, based on my own experience, about how to set things up to fit your needs. But the point I really want to stress is that it doesn't matter, in the long run, where you paint—the most important thing is to *paint.*

The Artist's
Daughter, Katherine,
24'' x 18'' (61 x 46 cm),
collection of the artist

The Instant Studio

One of the most common excuses for not painting is the complaint, "I do not have a studio, or a place to work." There is only one thing that is important about a studio and that is what comes out of it. Watercolor requires very little equipment. Besides your paints, brushes, and paper, everything else you need can be found in a kitchen. As a matter of fact, the kitchen table has probably doubled as a studio more than any other place. Use an old plate for a palette; find a rag and a cup (even a paper cup will do); and your excuses are gone.

There are a few simple improvements you can make on the kitchen-table studio. First, if you do not have a drawing board, use a cardboard or Masonite panel with a book or empty cup under the top edge, as shown in the illustration. This setup tilts your paper so that gravity carries your washes downhill. By moving the board and the book, you can change the direction of the flow, letting the wash run sideways, for example. Not only does this method allow you to "arrange" your drips, but it helps you to avoid puddles on the page because each drop of water tilts into a crevice in the paper. Also, you can angle the board for better viewing.

It does not matter if you stand or sit; just make sure you have a good view of the paper. If you are right-handed, put your palette and water on the right side of your painting; do the reverse if you are left-handed. That way you won't have to reach over your painting every time you go for your palette or water.

For your first studio or a temporary studio, use whatever light is there. Just make sure you start painting. But, for the record, sunlight is generally considered the best kind of light because it is usually white light and thus tends to keep the color true. Incandescent light combined with fluorescent light can be balanced to be almost as pure as sunlight. By itself, incandescent light tends to have a yellow cast, which is certainly manageable. Fluorescent light, however, is more difficult to manage, as its cool blue light can make warm colors look drab. Use a window or incandescent lighting if possible. But if fluorescent lighting is all that's available, use it.

By propping your board up on some books, you can use gravity to your advantage in painting washes. This angle also gives you a better view as you paint.

A pair of chairs can be used as an easel and a taboret.

A cardboard box with a notch cut into it serves as an easel and a handy storage bin.

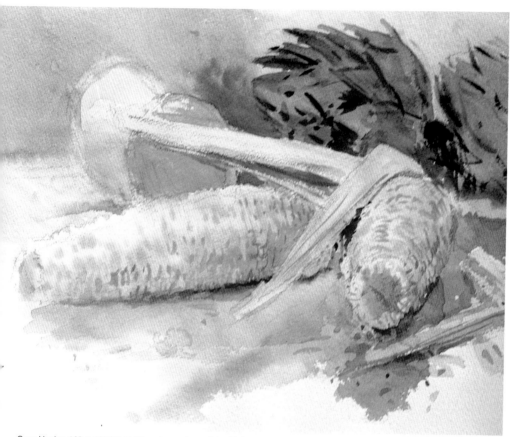

Corn Husks, 10" × 12" (25 × 30 cm), courtesy of the Esther Wells Collection

Anytime I am tempted to skip painting because of less than perfect conditions, I remember that Vincent Van Gogh once had only a piece of paper. He made a pen from a sharpened stick and drew with coffee grounds for ink. Paint and make do with whatever equipment you have. Fiddling with equipment is a way to procrastinate.

Having read all this, you may still feel you do not have the room to paint. But if you really want to get started in watercolor, you'll find a way. A small palette, paint tubes, and brushes can all fit into a shoebox, and a small block of watercolor paper serves as a built-in drawing board. All this can be taken out and used on the kitchen table, then thrown back into the box and put away in a few minutes. If you do not have a kitchen table handy, sit on the floor or prop your board on the back of a chair and use the seat of another chair to hold your equipment. I know several artists who cut the top of a cardboard box at an angle so a drawing board can rest in the notch. This makes an easel and a hideaway studio storage box. Put a little thought into it. You *can* have your studio.

This painting was done at one table, although not my kitchen or dining room table. My board was set on one side and the still life on the other. My palette, brushes, equipment: everything sat on this table.

For my subject, I chose some vegetables that happened to be available. Because the table was a dark wood and tended to absorb the color from the corn and oranges, I laid a piece of white drawing paper under the still life. That gave me a more reflective and luminous surface. I might add that the lighting was far from ideal—some fluorescent lights. They did, however, set up a system with light on the top and shadow on the bottom, which helped me define the form.

To begin this painting, I laid a light yellow wash over the page. This wash set up the basic color for the corn and the husks. And, because it was so light, everything else could be painted over it.

The most challenging part of this painting was to present the two ears of corn differently, keeping the two views distinct. On the left, where the ear of corn is in profile, I emphasized the shape. Notice how the clear line of the shadow moves all the way across the bottom, while at the top the orange and gray areas behind the corn outline its form. Conversely, with the corn on the right, the overall shape is deemphasized, and instead the circular pattern of the kernels is brought out.

The oranges and artichokes in the background are twofers, for they do a double job. Not only do they represent oranges and artichokes, but they frame the corn in the foreground. Notice, for example, how the rich dark green of the artichoke highlights the corn husks.

Now take a closer look at the husks, which have an interesting texture, indicated with some drybrush. This technique helps to render the form, and it adds a rough, raspy area, which is fun against all the washes in the painting.

Instant Studio

In the painting on the previous page, the lighting was only so-so. But here is a spot in my own home with excellent light. In my living room there's a bay window through which the light comes streaming in on plants in various stages of bloom. I hardly had to set up this still life; all I did was add the teapot.

The light from the window—primarily backlighting—added interest to the pots and especially to the white orchid blooms. It also set up cast shadows, which cut out intriguing shapes on the seat of the window. Even more important, the clean, white light from the window filled the living room, providing a balanced working light. That made it much easier to judge the mixtures on my palette and to see the true colors in my painting.

When I began this painting, the first thing I paid attention to was the location of the white flowers. These backlit flowers were so white that for the most part I used the white of the paper to paint them. After lightly penciling in their shapes, I added just a few touches of shadow color. Then I continued with the rest of the painting, taking care not to touch the white flowers— in essence, leaving them to paint themselves.

My next step was to study the light edges of the window mullions, which were only slightly darker in value than the white flowers. After washing these lights in, I painted the glowing reflected light on the bottom of the mullions, as well as on the teapot. Neither of these areas, however, came to life until the cool blue sky was introduced, complementing the warm orangish reflections. This is a good example of how one thing can paint another. Keep in mind that you're not painting objects in isolation, but rather the relationships between objects. If you look for these relationships, instead of seeing one object and then another, you'll find it easier to unify your painting.

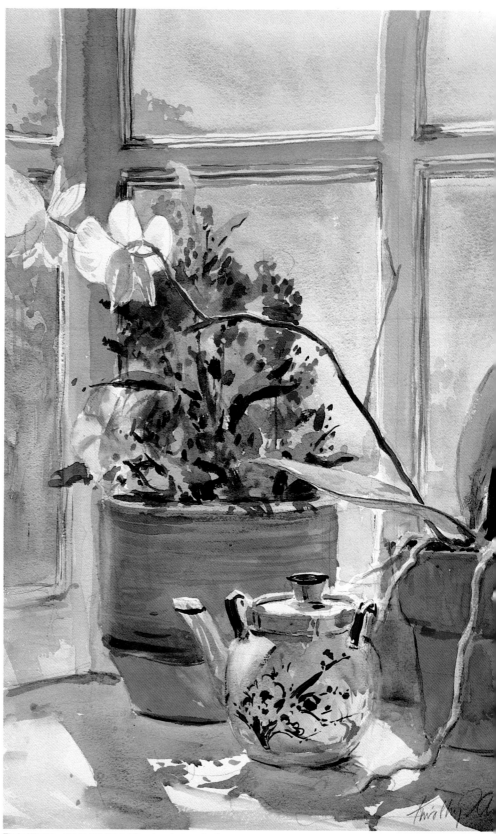

Tim's Window, 22″ × 15″ (56 × 38 cm), private collection

124

One day while I was teaching a landscape painting workshop in Cornwall, England, we were rained out. Rather than waste a painting session, I set up an instant studio in the hotel's tea room. It was not a studio for much more than four hours, but what a great studio it was. All I did was move a table, open a window, and borrow a chair. The painting serves as a demonstration of how you can improvise on a rainy day.

Notice, once again, the interplay between the complementary blues and oranges. Try to imagine the painting without the blues, and you'll get a sense of the important balance they provide. Also notice the different objects that are painted by their surroundings. The outline of the teapot shape, for example, is given by the strong colors around it. Similarly, the pictures on the wall are only minimally defined inside; the clear sense of their shapes comes primarily from the shadows behind them.

The main point here, however, is the idea of the instant studio. There are millions of situations like the three I have shown you. Whether you work on your kitchen table or paint the view from a hotel window, the important thing is to make do with whatever facilities are available and to paint as much as you can. I often think of my studio in terms of time rather than location. It doesn't matter where I paint as long as I put in my studio hours.

Cornwall Morning, 30″ × 22″ (76 × 56 cm), collection of Mr. and Mrs. Richard Randolph

The Outdoor Studio

The heading "Outdoor Studio" probably conjures up landscape painting. But, as you may have guessed by now, I believe painting is painting. You can do a portrait or a still life or anything else you desire outdoors. And, because watercolor is so portable, it is ideal for taking out on location.

Why paint outdoors? Augustus John, the English portrait painter, said it well: "The studio door closes out the world." Going outside to the source for inspiration lends an impetus that memory or photos can rarely match. The wind, smells of trees and grass, and changing sun all add to the immediacy of painting outdoors. Sensing and experiencing these different stimuli encourage interpretation as opposed to copying. And there's an added benefit: when I paint outdoors I always find that my color is truer.

Although photographs can be helpful for painting in the studio on a rainy day, they sometimes give you wrong information. Working outside, on the spot, it's easier to choose what you want to see. If something annoys me, I just don't see it. Often I've been approached while painting outdoors and asked if I'm going to put a trash can or parked car (or something similar) in my painting. Until the person mentioned it, I didn't even notice the object—that's how selective my vision is.

A photograph can also be misleading in terms of color. Unless you're a professional photographer, it's hard to capture color in the same special way that you, individually, see it. The more I become aware of the range of color that I see outdoors, the more I am convinced that painting directly from life is for me.

Of course, there are some problems in working outdoors. One of the main issues is comfort, so here are some tips.

First of all, wear a hat with a brim. You may be surprised that a hat is a key piece of painting equipment, but protecting your eyes from the sun is very, very important. John Singer Sargent once remarked on the fact that the Impressionists all wore hats, which allowed their pupils to open up and let brighter light in. If you've ever sat outside reading a book and then looked up, you may have noticed that everything seems somewhat gray.

Shaw's Cove, 22" × 15" (56 × 38 cm), private collection

Shaw's Cove is only ten miles or so from my home. Midweek in early spring there was no one on the beach, and it was as peaceful as it was beautiful. I set myself up to be comfortable, using a wooden watercolor easel and sitting on a folding stool, with my paintbox on the sand and my palette on top. I also stuck an umbrella in the sand to reduce the glare of the sun. Fortunately, since the day was unseasonably hot, I had my swimsuit on under my clothes, so I was able to take a quick dip during a break. Now there are some good points to photographs as a source for a painting, but I never swam in one on a break!

One of the challenges in this painting was depicting the two successive cliffs on the left. To bring out the closer one, I emphasized the cast shadow and played up the color of the flowers on top. The flowers and shadows on the rear cliff were actually almost equally powerful, but I had to use softer, more muted color to keep this cliff from jumping forward.

There is a twisting feel to the form in this painting, especially on the back cliff, culminating in the gazebo. Notice that the gazebo frame is made up of four basic values and colors: a white section in the light, a cool dark in front, a warm dark inside, and some neutral dark accents. These simple changes help to define the form and move the eye around it. Also notice that, even though the dark roof points straight up, the decorative pattern just beneath it and the glowing reflected light attract our eyes and bring us back to explore the painting. The rocks, water, and figure in the foreground also direct our attention, zigzagging back to the cliffs.

The reason is that your pupils have contracted, letting less light in and thus diminishing the brightness of the color you see. Wearing a hat allows you to see more vivid color, leading to richer paintings.

A second tip is to use an easel and a small camp stool (or you can stand). The easel not only holds your painting but also enables you to turn it out of direct sunlight. That way you don't have to worry about the bright light reflecting off the paper and knocking out your ability to make good color judgments. (This is especially important if there's no source of shade on the spot.) An easel also makes it easier to step back to view your work and check your progress as you are plugging along. Moreover, with a good watercolor easel, you can tilt the board to control the flow of your washes.

Another important aspect of comfort is dressing for the day. In cooler weather that means layering—you can always take off jackets and sweaters if it gets warmer.

On a hot day you might even take along a bathing suit, especially if there's the chance of a quick dip.

In addition to the problem of comfort, there's the difficulty of changing conditions outdoors. My advice is: create your idea and follow it. Too often I've seen students start with a great idea and then the light changes or a cow wanders into the scene, so they make major changes, trying to accommodate the new information and in the process ruining the initial composition. Before putting paint on the paper, I try to grasp the concept in my mind; I may even make a compositional sketch or a color note. Then, as I paint, I know in my mind's eye what I want. If I've done a sketch, it serves as a map to the goal in my head, while the subject on hand is a continuing inspiration and resource. The point is that the responsibility for the painting lies with the artist, not the landscape. Don't just copy nature. Use your head and plan what you want.

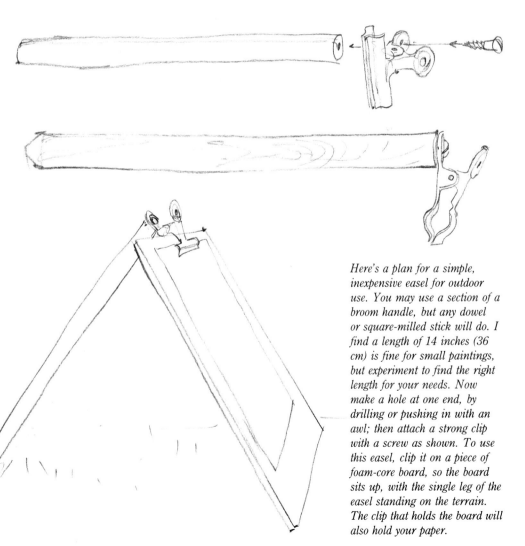

Here's a plan for a simple, inexpensive easel for outdoor use. You may use a section of a broom handle, but any dowel or square-milled stick will do. I find a length of 14 inches (36 cm) is fine for small paintings, but experiment to find the right length for your needs. Now make a hole at one end, by drilling or pushing in with an awl; then attach a strong clip with a screw as shown. To use this easel, clip it on a piece of foam-core board, so the board sits up, with the single leg of the easel standing on the terrain. The clip that holds the board will also hold your paper.

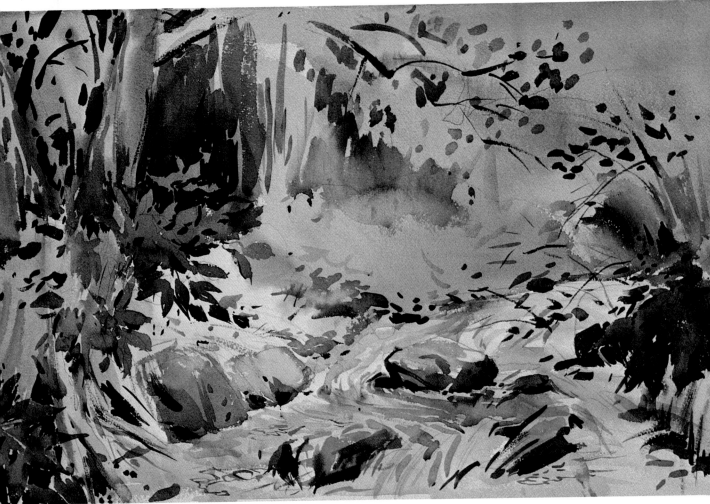

Tyrolean Stream, 13″ × 20″ (33 × 51 cm), collection of Pat Struble

This painting wouldn't have had a chance if I didn't enjoy painting outdoors. While walking on the outskirts of an Alpine village, I heard the running water of the stream and then went through some trees to find it. It came complete with a bridge, just sturdy enough to hold me and my equipment. There I sat on the rickety wooden bridge, with the trees arching over me and the stream rushing just inches below. The lights and the leaves flickered with every stirring of the breeze. Nature enveloped me.

Those few hours are among the most enjoyable painting hours I have ever spent. My imagination was stimulated, and I felt free to interpret what I saw. I do not remember exactly how I painted this. Instead, I just let go, allowing my instincts free rein and letting my painting skills function on their own. The looseness of the brushwork in both the trees and the water helps to express the carefree beauty of this spot.

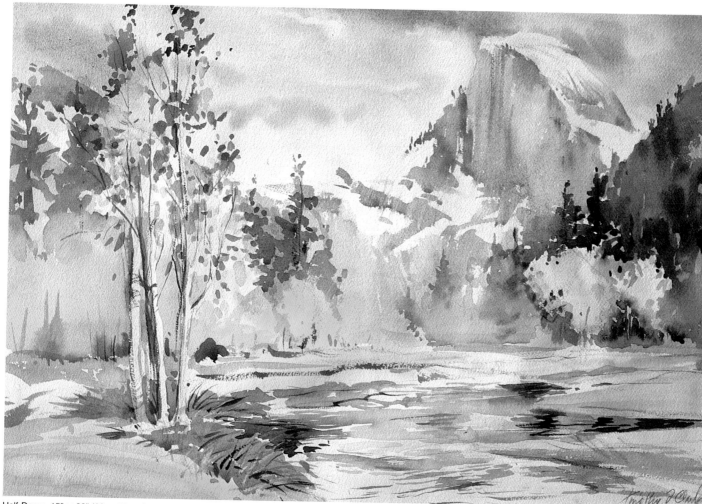

Half-Dome, 15″ × 22″ (38 × 56 cm), collection of Pat Rowland

Half-Dome in Yosemite National Park is known for its monumental beauty, and many artists, including Albert Bierstadt and Thomas Moran, have expressed that beauty. Unfortunately, on my first day in Yosemite, it snowed so hard even I couldn't paint outside. By the next morning the trees had all turned into brilliant fall hues, and the urge to paint this scene was compelling. The temperature, however, was still rather chilly, so I prepared myself well.

To start, I had a hot breakfast, and some kind soul brought me coffee a few times while I was painting. I dressed in layers, and I needed every layer. On my head I wore a hat—not just to shade my eyes, but also to keep my head warm. For my hands, I used a pair of gloves with the top half of the fingers cut off to allow flexibility. In

addition to wearing a good pair of thermal socks, I kept my toes warm by wiggling them. And every half-hour or so, I'd get up and walk around. Of course, if you start to get frostbite or really chilled, you should go inside, but don't pass up the opportunity for a good day's painting because of a little cold weather.

With this painting, I was so charged up by the scene that I painted it on "auto-pilot," letting the beauty of the area run through me. In retrospect I can see how the darks of the pine trees make the yellow trees on the bank look even brighter. These yellow trees are complemented by the purple sky and the cool gray mountains. Also notice the highlights scraped out of the grass in front and the wet-into-wet technique used to show the trees receding along the river.

A Permanent Studio

About ten years ago I invited a class over to see my studio. They were interested in my paintings in progress, and of course they wanted to see my equipment: my easel, brushes, lighting setup, and storage facilities. The trouble was that afterward the students complained that they didn't have the proper conditions to paint in. At the time my studio was rather elaborate; now it's much smaller, yet I paint more in it and, I hope, better. As I've stressed repeatedly, it doesn't matter what your studio space is like—just use it.

Still, it doesn't hurt to talk about the ideal studio. Essentially, what I'd look for is a quiet place with decent light. Some specific guidelines follow.

Traditionally, the main windows should face north and be fairly high. North light provides a relatively even light, whereas if the windows face east, west, or south, the light and shadow will change as the sun moves, shifting from morning to noon to afternoon. Although north light is slightly cool, it still gives you relatively pure color, making color mixing much easier. But don't let these remarks discourage you from using south, east, or west light. Many artists are quite happy with this kind of light. What they do is cover their windows with muslin, which produces consistent lighting throughout the day.

In addition to window light, you also need electric lighting—especially for overcast days and nighttime painting. I prefer overhead track lights so I can control the direction of the light. Since the incandescent track lights tend to glow a bit warm on their own, I add a single cool fluorescent bulb as a balance. Some artists use all fluorescents, mixing warm and cool tubes. This can work fine, but I find the diffused quality of the light and its tendency to flicker annoying.

In terms of size, make sure you have enough room to walk a few feet away from your easel or drawing table to check on your work's progress from a distance. If you work from live models, you'll need

This easel has three main adjustments: one for the height, one for the angle, and one to turn the work upside down for fresh viewing or to control drips.

even more room. Also make sure there's adequate ventilation, especially if you intend to use airbrush techniques.

The choice of an easel depends on personal taste. Some artists like to work on a hydraulic-powered drawing table, while others prefer a simple utility table. My own choice lies in between—it's a sturdy, single-post drawing table, with the height and angles fully adjustable (see the illustration). With this easel, I can even turn my painting upside down. After fifteen years of use, I'm very comfortable with it. It was a gift to myself after art school, and I wouldn't dream of changing it.

For a taboret to hold your materials, water, and palette, you can buy a specially designed artist's cabinet or just use the corner of a table. When I sit down to paint, I sometimes place my water and palette on the floor. I find this arrangement comfortable because it keeps the distance between my eyes and my palette and my eyes and the painting about the same. That means I can look from my palette to the easel without refocusing, which makes color mixing easier.

Another important item is a storage area for clean paper, finished paintings, and works in progress. A wooden or metal flat file is a good professional investment. As an alternative, you might try the special cardboard boxes offered by some art suppliers and mail-order houses. The cardboard boxes that watercolor paper is shipped in can also be used for storage.

One final item that you should not be without is a library. This can take the form of a scrap file of prints that you like, or it may consist of books on your favorite artists. But it's important to build a resource center that you can go to for inspiration and information. Don Graham, who taught drawing and composition at Chouinard Art School in Los Angeles and the Disney Studios, once pointed out to me that you pay a lot of tuition for school and when the semester is over, all you have is what you can remember; but when you acquire a book, you have it forever.

This is the watercolor corner of my studio. To me, the most important aspect is the color-balanced light. Why? Because much of my studio time is spent finishing paintings started on location, so I need a similar kind of light.

Notice the variety of brushes, the flat files, and the rolls of paper. At the upper right you can see my rear-projection viewer—a useful piece of equipment, even though I generally prefer to work from life. On the left you can glimpse the corner of my oil easel (yes, I do paint in oil). And in the center is my watercolor easel. When I'm seated, working at this easel, my taboret is on my left because I'm left-handed. Remember: to avoid reaching across your painting, put your palette on the same side as your working hand.

As you can see, my studio is a combination of old and new. The important thing in choosing equipment is to find out what works for you and then to use it.

I like to keep this portable easel nearby, both in the studio and on location. As you can see, it's quite flexible, allowing me to tilt the paper in different directions.

J. M. W. Turner, **Beaubraris Castle** (detail), courtesy of the Huntington Library and Art Collections, San Marino, California

A BRIEF LOOK AT WATERCOLOR HISTORY

To test the purity of gold, you can rub a piece of gold jewelry or a gold nugget against a touchstone. There is no true touchstone for art, however; people continue to search for some kind of measuring stick to gauge the quality of an artwork. You've probably heard of artists who had to struggle to make ends meet during their lifetime, but received wide recognition after their death. And there are artists who were quite famous in their day, but whom almost no one has heard of today. Different styles and different techniques go in and out of fashion.

The closest you can come to a touchstone is to look at paintings in museums, by artists who have withstood the test of time. Although it's not imperative, it's a great help to have access to a good museum—or at least good reproductions. Major artists, like the ones included in this chapter, can teach you a lot about composition and the elements of design—line, color, value, and so on. But even more important, they can show you what I call the "raw creative language." It doesn't matter whether the style is realistic or abstract—in great art there's an element of daring, of risk-taking. The artist is talking about what's important to him or her, rather than just going along, in step, with the rest of the world.

Studying the history of watercolor can thus provide you with an ongoing source of inspiration. It can also serve as a counterpoint to current fashions in watercolor. Today, for example, there's a tendency to extol the transparency of watercolor while downgrading any use of white. But when you look at the past, you find that many important artists used body color—including J. M. W. Turner.

In one sense it could be said that the history of watercolor goes back to the earliest paintings. Cave art was done with a simple gum or animal glue, mixed with pigment and diluted with water—making it a form of watercolor. Throughout much of art history, however, watercolor was used as a secondary medium by artists working in oil or other media. Albrecht Dürer and Claude Lorraine, for example, worked in watercolor, although it was not their primary medium. Then, in the early nineteenth century, watercolor came into its own, growing out of the British tradition of topographical drawings, which recorded geographical and architectural information for explorers and surveyors.

In general I see the history of watercolor moving from the topographical tradition into the more atmospheric depictions of Thomas Girtin, J. M. W. Turner, and Richard Parkes Bonington. American artists, such as Winslow Homer and John Singer Sargent, were influenced by the British watercolorists, but they added their own personal vision. In the twentieth century artists like Edward Hopper, John Marin, and Georgia O'Keeffe have pushed the expressive element even further, in both realistic and abstract modes.

Of course, there are many other artists whose work I could have chosen for this chapter. The examples here are just to get you thinking.

133

Thomas Girtin, **Rainbow on the Exe**, 1800, watercolor,
courtesy of the Huntington Library and Art Collections

*Thomas Girtin (1775–1802) did this delightful painting when he
was twenty-five, just two years before his untimely death. Although
trained in the topographical tradition, he was beginning to move
beyond this, displaying a greater interest in atmospheric conditions
and expressing a more personal vision. It is thought that Girtin had
a tremendous influence on his contemporary and friend J. M. W.
Turner. Turner himself is said to have remarked, "If Girtin had
lived, I would have starved."*

*When you look at this painting, it is much more than a
description of the terrain and a rainbow. It is executed with an
immediacy that puts it beyond the common technique of the day. The
figures are added, not out of allegiance to the scene, but to
animate the painting. Note the subdued color everywhere but the
rainbow. This control of intensity clearly directs us to the center of
interest, adding to the drama of the painting.*

J. M. W. Turner, **Beaubraris Castle**, 1827—1838, watercolor, 11 5/8″ × 16 3/4″
(30 × 43 cm), courtesy of the Huntington Library and Art Collections

*Like his friend Thomas Girtin, Joseph Mallord William Turner
(1775—1851) was trained in the topographical tradition of
watercolor. His work also began to show a greater concern for color
and atmospheric conditions. In his later paintings the handling of
light and color becomes even more important than the subject.*

*Although Turner completed more than 20,000 works on paper,
many were simple sketches or atmospheric studies, not meant for
exhibition. This painting, however, is an example of his finished
work, part of a series that was later engraved and printed by
W. C. Smith. It clearly shows Turner's roots in the topographical
condition, as well as his concern for light and atmosphere. Notice
how the background mountains function as a misty, luminous blue
area in the painting and how the red pants of the foreground figure
serve as an important balancing accent for all the soft, cool areas.*

*Turner built this painting with layers of washes, carefully
playing details against looser background washes. The technique is
complicated, employing both transparent and body color (with white
added). Some parts have been scrubbed out, back to the white of the
paper. The final result is a feeling of color combined with light.*

Thomas Shotter Boys, **Chateau Espagnol, Near Brussels,** watercolor, 7″ × 10 1/2″ (18 × 27 cm), courtesy of the Huntington Library and Art Collections

Thomas Shotter Boys (1803–1874) is included here as a contemporary and follower of Richard Parkes Bonington. These artists have been described as virtuoso painters, combining a free handling of the paint with solid drawing to arrive at a kind of spontaneous realism. Their work set the stage for the fresh and simple use of watercolor that remains popular today. It is quite likely that John Singer Sargent was influenced by Bonington and his followers.

Notice the economy of the brushwork in this painting by Boys. The sky and the background are done with a minimum number of strokes. The shapes of the shadows, the windows, and the trees are all rendered with simple strokes, with an eye to the overall design. Even the figures show a calligraphy in keeping with the casual feeling of the piece.

Winslow Homer, **The Pioneer**, watercolor on paper, 1900, 13 7/8″ × 21″
(35 × 53 cm), courtesy of the Metropolitan Museum of Art, Amelia B. Lazarus
Fund, 1910. Reproduction © 1985 by the Metropolitan Museum of Art.

*Winslow Homer (1836–1910) did not begin to paint seriously in
watercolor until he was thirty-seven years old, when he was
already an accomplished oil painter. He brought his own personal
vision to the medium, using simple shapes and broad washes to
summarize what he saw, rather than laboriously copying every
detail. Although he occasionally used a dab of white for highlights,
he is known for his pure, transparent washes.*

*This painting, done fairly late in Homer's career, is really quite
simple in execution and design. Notice the importance of the
skyline shape and how the lights and darks play against each other
in a tightly knit, yet seemingly spontaneous, design. The painting of
the man, hill, and trees is much more than a depiction of nature;
each area works as an important shape in the overall composition.
The strong light-dark contrast then brings a certain majestic clarity
to the whole.*

John Singer Sargent, **Camp at Lake O'Hara,** watercolor, 15 3/4″ × 21″ (40 × 53 cm), courtesy of the Metropolitan Museum of Art, gift of Mrs. David Hecht, in memory of her son Victor D. Hecht, 1932. Reproduction © 1987 by the Metropolitan Museum of Art.

Although John Singer Sargent (1856–1925) is probably best known for his oil portraits, he did some wonderfully fresh and spontaneous watercolor paintings. This painting reveals several of his ongoing interests—in the different colors of white, in the fleeting effects of light, and in the virtuoso handling of paint. Look, for example, at the way Sargent has treated the whites in the tents. There's a balance of warm and cool colors in the play of subtle reflections and shadows. Also notice how the contrast of the dark trees on the left helps to make the front tent appear white. At the same time the dark trees act as a compositional framing device, closing the background and bringing attention to the opening in the front tent.

Now notice the somewhat surprising lighting system in this painting: the campground is in shadow and the only area in full sunlight is in the distance. Finally, pay attention to the fluid, loose handling of the paint throughout. Hard and soft edges, wet and dry passages, all seem to be painted with equal ease. Although in this case Sargent worked with transparent washes, it was not uncommon for him to use thick whites in some areas, if the white of the paper had disappeared.

John Marin (1870–1953) took freedom of expression to a new level. He lived in Europe, mainly in Paris, from 1905 to 1909, during the formative years of abstract art, and his work was included in the famous 1913 Armory Show in New York, which brought avant-garde art to attention in the United States. His paintings, whether of New York or later of the Maine coast, make a clear break with the topographical tradition: emphasis is on expression, not description.

In this painting the turning and swaying bridge suggests the bustle of New York. Notice the animated quality of the brushwork and how this contributes to the feeling of movement in the whole. The breaking up of the form may be influenced by Cubism, but the vision here is a personal one and very much Marin's own.

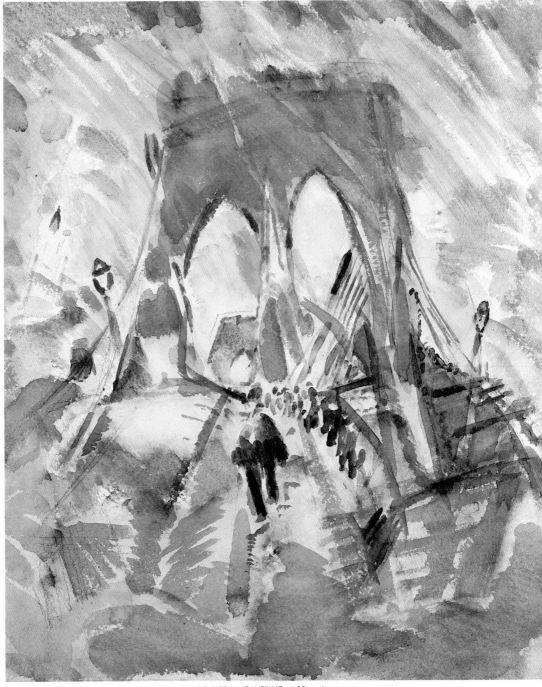

John Marin, **Brooklyn Bridge**, 1910, watercolor, 18 1/2″ × 15 1/2″ (47 × 39 cm), courtesy of the Metropolitan Museum of Art, the Alfred Stieglitz Collection, 1949. Reproduction © 1985 by the Metropolitan Museum of Art.

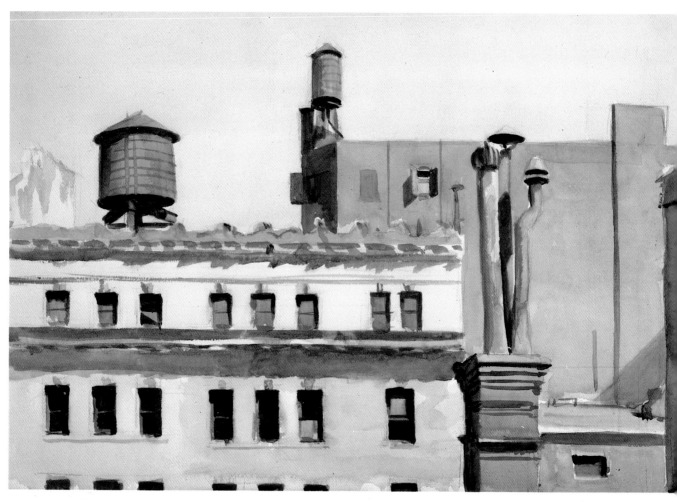

Edward Hopper, **Rooftops**, c. 1926, watercolor, 13 1/16″ × 20″ (33 × 51 cm),
courtesy of the Whitney Museum of American Art, Josephine N. Hopper Bequest, Acq. 70.1114

*Edward Hopper (1882–1967) carried on the figurative tradition in a
predominantly abstract era. In New York he studied with Robert
Henri, who emphasized the driving, thriving life of the city.
Hopper, however, shows us a different aspect of urban America—its
solitude, how it's possible to be surrounded and yet alone.*

*Hopper's style couldn't be more different from Marin's. Although
he was aware of the European avant-garde, his work remained
seemingly aloof from these movements. Instead, he painted in a
straightforward manner, somehow capturing an eerie quality of
light, which gives his paintings their highly personal flavor.*

*The silent, monumental quality of the cityscape shown here is
achieved by the strong light and dark contrasts, as well as the
horizontal format and conspicuous lack of human presence. What's
remarkable is the way Hopper is able to share his vision of urban
solitude with such relatively simple means.*

In Georgia O'Keeffe (1887– 1986) the spirit of art burned for almost a century. She first began to show her work in 1916, in the New York gallery directed by Alfred Stieglitz, the well-known photographer. Later, in 1924, she and Stieglitz married.

O'Keeffe reacted to her environment—whether the cityscape of New York or the landscape of New Mexico— with an eye for flat shapes. Her works—whether they depict buildings, suggest plant forms, or are totally abstract— might be described as icons. The simple, direct execution of the flattened form fills the page with an emotional strength that bucks sentimentality.

This particular painting shows the expressive pos- sibilities of just a few forms and a very limited palette. Its power lies in its straightforward directness and the quick boldness of the brushwork. Notice how the composition and shapes themselves suggest some kind of organic growth, even though the painting remains abstract.

Georgia O'Keeffe, **Blue #3**, 1916, watercolor on tissue paper, 15 7/8″ × 10 15/16″ (40 × 28 cm), courtesy of the Brooklyn Museum, 58.75, Dick S. Ramsay Fund

ON PERMANENCY

Paint

All too often watercolor artists don't take the time to learn about their pigments and then are surprised to see their paintings fade or change in color. But this doesn't have to happen. Watercolor can be as permanent as any other medium, if you take care in choosing colors and use a professional, not a student, grade.

To help you in the selection of pigments, I've included three lists. The first list—of extremely permanent pigments—is obviously the most stable. With the second list, the relatively permanent colors, you may encounter problems under less than ideal conditions, but usually these colors are considered permanent. Finally, the third list contains some popular colors that fluctuate in quality, so there's a relatively high risk of impermanence. Even though these colors are seductive, it's best to avoid them.

List 1.
Extremely Permanent Pigments

Burnt sienna
Burnt umber
Cerulean blue
Charcoal gray
Chinese white
Cobalt blue
Cobalt violet
Davy's gray
Indian red
Ivory black
Lamp black
Lemon yellow
Light red
Oxide of chromium
Raw sienna
Raw umber
Sepia
Sepia, warm
Terre verte
Venetian red
Viridian
Yellow ochre

List 2.
Relatively Permanent Pigments

Alizarin crimson*
Cadmium orange**
Cadmium red**
Cadmium red deep**
Cadmium yellow**
Cadmium yellow deep**
Cadmium yellow pale**
Cobalt green
Cobalt turquoise
Cobalt yellow (aureolin)**
Hansa yellow
Indian yellow
Mars colors (all)
Phthalo blue
Phthalo green
Quinacridone (permanent rose, permanent magenta)
Rose madder genuine
Ultramarine blue
Vermilion***

List 3.
Risky Pigments

Carmine
Chrome colors (all)
Gamboge
Hooker's green
Prussian blue
Sap green
Vandyke brown

As you choose your palette from the first and second lists, bear in mind that there are many possible combinations—there is no single "right" palette for watercolor. I'd recommend, however, that you avoid pre-mixed colors, such as Payne's gray (alizarin crimson, Prussian

*Alizarin crimson is not reliable in thin washes.
**The cadmium colors, along with cobalt yellow (aureolin) are very useful; their only defect is that they may change in damp or very humid areas.
***Vermilion should be protected from direct sunlight.

blue, and black) and olive green (raw sienna and phthalo green). If you need to use one of these colors, it's best to mix it yourself so you get a more personal and unique hue.

In addition to rating permanence, some books list pigments according to their transparency and staining power. In my opinion, however, all watercolor pigments (even white) become transparent when they are thinned with enough water. It's best to learn about any differences in transparency through experience, instead of reading a list.

As you work, keep in mind that tube paint is designed to stay moist. Keep your palette moist and covered between sessions so the paint won't dry out. You can also use cakes of paint, which don't dry out and thus last longer.

Paper

Choosing good-quality paper is also important in making your watercolors permanent. The best is 100% rag watercolor paper, although some acid-neutral pulp papers may also be okay. If you select a top-quality paper, it won't turn brown or react chemically with the paint over time.

Another problem with paper—buckling—usually comes from uneven wetting. One way to avoid this is to mount the paper on a rigid board. This process, however, destroys the deckle edges. Because I like to preserve the deckle edges, I almost never stretch or mount my paper. Generally I use 140-pound cold-pressed paper and one or two clips to hold it to my board, so the paper can expand when it becomes wet. If you use more than two clips or several tacks, the paper tends to buckle because it is too hemmed in.

Even when there is severe buckling, it need not be a disaster. Try carefully moistening the back of the paper and placing the painting between two pieces of particle board; then weight this down with books. After two or three days, the paper should be completely flat again.

Framing

The final step in permanent painting is proper care of the finished work. Protect your watercolor by mounting it in pH-balanced mats with pH-balanced tape. Cover it with glass or Plexiglas (Plexiglas with ultraviolet protection provides extra insurance against light damage). Never display your watercolor (or any other painting) so that it's hit by direct sunlight. Also keep your paintings out of high-humidity areas, such as bathrooms.

Here's a final tip. A bag like this can serve as a handy portable studio, with room for all your basic materials.

INDEX